BENT, BOUND & STITCHED

Collage, Cards and Jewelry with a Twist

GIUSEPPINA "JOSIE" CIRINCIONE

NORTH LIGHT BOOKS
Cincinnati, Ohio

www.mycraftivity.com

12 11 10 09 08 5 4 3 2 1

Distributed in Canada by Fraser Direct
100 Armstrong Avenue
Georgetown, ON, Canada L7G 5S4
Tel: (905) 877-4411

Distributed in the U.K. and Europe by David & Charles
Brunel House, Newton Abbot, Devon, TQ12 4PU, England
Tel: (+44) 1626 323200, Fax: (+44) 1626 323319
E-mail: postmaster@davidandcharles.co.uk

Distributed in Australia by Capricorn Link
P.O. Box 704, S. Windsor, NSW 2756 Australia
Tel: (02) 4577-3555

Library of Congress Cataloging-in-Publication Data

Cirincione, Giuseppina.
 Bent, bound & stitched : collage, cards and jewelry with a twist
/ Giuseppina "Josie" Cirincione. -- 1st ed.
 p. cm.
 Includes index.
 ISBN-13: 978-1-60061-060-8 (pbk. : alk. paper)
 1. Wire craft. 2. Greeting cards. 3. Jewelry making. I. Title.
TT214.3.C57 2008
745.594'2--dc22
 2007037194

Editor: Tonia Davenport
Designers: Karla Baker, Marissa Bowers
Production Coordinator: Greg Nock
Photographers: Christine Polomsky, Al Parrish

fw
F+W PUBLICATIONS, INC
www.fwpublications.com

DEDICATION

To my parents, who don't always understand what I am up to but always have a smile on their faces when they say, "Just be careful and do whatever makes you happy."

To Nick for all his love and support, his amazing family, and for bringing little Hank into our lives.

To my brother and his wife for all their encouraging words.

To Bella and Vita for penciling me in.

To Tonia for a great end to a long week.

To Beth for being a wonderful friend and confidant.

To everyone out there who supports the crafting industry.

Lastly, to Sirius Satellite Radio, with its unspeakable humor, great music lineups and not-so-one-sided talk radio, for keeping me company for hours on end while I pounded away in my workroom.

ACKNOWLEDGMENTS

Part of the joy of my second book has been getting to know the people at F+W Publications who were so supportive of my first book. My heartfelt thanks goes to Tonia Davenport, my editor and, more importantly, a true friend. She is a great motivator and advisor. To Jay Staten, who brings a wealth of experience and great advice to the table. To Christine Polomsky, whose mad digital camera skills magically turned blocks of discarded wood into a jeweler's bench. To Greg Hatfield and the marketing/sales department, for all their help at shows and promoting the book. To Marissa, Karla and the design team, who in the end, magically make everything look amazing.

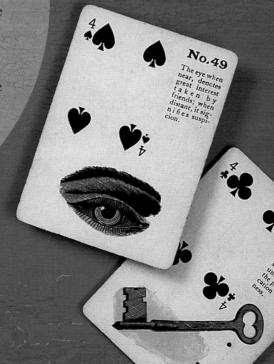

No.49
The eye when near, denotes great interest taken by friends; when distant, it signifies suspicion.

CONTENTS

CHECK YOUR DRAWERS

At first I wasn't sure which direction to go with ideas for a second book. I'd already shared so much of myself—and my work—in *Collage Lost and Found*. What new things could I offer? Was there anything that hadn't already been done? Was I going to have to spend weeks scouring every store in town for new products and the latest and greatest trends? The thought made me dizzy and I felt the need to sit down. That's when I realized I didn't need a seat. All I had to do was take a step backward (not a big one— too much stuff in my workroom would make that hazardous) and look at the overflowing containers surrounding me. The things I'd amassed over the past few years with the hopes of someday incorporating into a new book—the inspiring papers, embellishments, inks, ephemera and so on—were staring back at me. One by one I lifted the contain-

ers off the shelf, removed the lids, peered inside and poked around, and the ideas I had when I first laid eyes on those objects came back.

I don't scrapbook, and I have a love/hate relationship with scrapbook paper. I love it so much that I can't resist it, and I have a hate complex with myself every time I buy another sheet of it. With the new sophistication of patterns, colors and textures, it mimics another of my many obsessions—vintage textiles. Over time, a tower of scrapbook paper in my studio grew and grew until it was infringing on my already wee work area; so instead of using cardstock for stamping, I started stamping on scrapbook paper.

Another thing that I have amassed is a collection of wire—different types and colors, large and small gauges and of course a menagerie of wire-bending tools. The way I bought the tangled coils was the way I still found them—among other cramped supplies in crowded (but nicely labeled) storage drawers with identifiers such as "doll hands," "tiny watch parts," "misc. found-on-the-ground bits and pieces that will one day adorn a collage" . . . you get the idea. Open drawers, find inspiration.

So I thought, why not marry the wire and the scrapbook paper together and make cards? Thus began the inspiration for projects in the book's first section, "Folded." The wire offered new possibilities for unique embellishments, my own style fonts and a different way to add dimensional texture to the already beautiful piles of scrapbook paper.

Then, I got to thinking about how many beautiful cards I've received from others over the years with not enough wall space to frame them all. I imagined other people in the same boat and perhaps even worse off than me, having collections of artful ATCs, but keeping them hidden away in a binder. Store-bought card stands and displays left much to be desired. So, I decided to make my own dimensional holders. I opened my drawer of many wires and began wrapping and twisting to my heart's content. I found that displaying my collected treasures in handmade, dimensional stands gave artwork or photographs a completely different look. This turned into the second section of the book, called "Wrapped."

Then, of course, after dealing more with dimensional pieces, I returned to my love of jewelry. Found-object jewelry is not a new concept, but it goes hand-in-hand with recycling or using what you have. As I mentioned before, this was about cleaning up and looking at objects in a new light. It's one of the few times when wrinkles and tears are appreciated and considered a thing of beauty (those of you who check the 40- to 45-year-old box will understand). The final section of this book, called "Worn," explores cold connections and techniques that, when paired with your imagination, will give you the ability to breathe new life into someone's discarded objects.

The projects and techniques I chose to showcase on the following pages are easily applied to many different mediums and ideas. What I hope you get out of this book are approaches to some new and some tried-and-true techniques that you can take and expand on your own for your own unique creations.

SIMPLE SUPPLIES

Most of the supplies used throughout this book are basic.

The few things that you may not already own are readily available from local craft, stamp, scrapbook or hardware stores, or they can be found with the help of the resource list on page 124.

I encourage you to look through your own drawers. Like me, you might be surprised at what treasures are lurking in all of those containers.

WIRE

Here's what I love about annealed wire: It is readily available, it is affordable, it comes in a number of gauges (though I use 19-, 20- and 28-gauge most often) and the blackened color lends itself nicely to found-object jewelry. When sanded, it takes on a pewter finish. It is soft enough to form and hammer but it is a strong, hardy material. Because it's so affordable, it is the perfect wire to use while honing your wire-forming skills.

Baling wire makes the perfect rivet and a $\frac{1}{16}$" (2mm) drill bit makes the perfect companion. This is the best wire to use for heavier findings. While it's typically 16-gauge, it is not always labeled with a gauge when you buy it. Other types of wire, including nickel and copper, provide an easy way to add color and individuality to your work.

SHEET METAL

Like wire, sheet metal is available in a number of different gauges and types. It can be cut with metal snips or a jeweler's saw. Copper and nickel silver are the two types used for the projects in this book.

SCRAPBOOK PAPER

The designs, complex hues and textures of today's papers are luscious and offer uses that go far beyond the scrapbook. The card projects throughout this book take advantage of diverse and awe-inspiring patterns. The weight of the paper is another plus. You can paint, sew, stamp, draw on and fold it without the paper tearing or falling apart.

STAMPING INKS

The two brands of ink that never leave my work table are StazOn and Palette Hybrid inkpads. There is nothing more frustrating than stamping an image and picking up your work only to find the ink is not dry and you smudged it. The Palette inks dry quickly, so smudges are not a problem, and I love StazOn because it does just that—stays on. The colors are abundant and, because of their staying power, the inks can be used for a multitude of applications. In addition to StazOn and Palette, I also like using Encore metallic ink in gold every now and again for a bit of shimmer and interest. I typically use a limited number of colors, just to make my life easier. You'll find a total of seven colors used in this book.

PALETTE INKPADS: Noir, Burnt Umber and Ballet Blue

STAZON INKPADS: Jet Black, Blazing Red and Teal Blue

ENCORE INKPAD: Gold

ACRYLIC CRAFT PAINTS

I use acrylic paint to add dotted and dashed lines of color for an interesting texture over paper. For the projects in the book, basic craft paints will do. When choosing the colors for the projects in the book I drew my inspiration from Folk Art, Americana (Lamp Black, Santa Red, Antique Gold and Desert Turquoise).

IRIDESCENT GEL PEN

To add flecks of shimmer to scrapbook paper, I recommend using Sakura's Gelly Roll iridescent clear pen. The clear quality allows the base color of the paper to shine through. Try using it on photocopies to highlight sections of a photograph or on scrapbook paper to draw attention to certain parts of a pattern. This pen has earned a permanent home in my basic list of supplies. One even lives in the depths of my purse. Sakura offers a wide variety of glitter pens. I suggest trying them all. For more dimensional sparkle, try Ranger's Stickles.

COLORED CHALKS

To add layers of color to black-and-white photographs, I like using Artistic Blending Chalks (Inkadinkado). The quick application mimics the look of vintage hand-colored photographs. It is an effortless way to give new life to run-of-the-mill photos. I suggest copying your images onto a high-quality, uncoated paper; chalk will not stick to glossy photo paper.

VINTAGE AND OTHER IMAGES

You don't need to go far to find imagery that sparks the imagination. If rummaging through bins of old photos is not to your liking, just log onto the Internet. There is a plethora of choices. If you want to turn your image into a silk screen or a metal etching, look for images that are high in contrast or use photo-imaging software to bump up the contrast levels.

ADHESIVES

The types of adhesives I always have on hand are an all-purpose craft glue for securing embellishments and wire letters, a glue stick for areas of paper that are large, double-sided tape to quickly tack things in place and gel medium for layering papers. Each has its place.

ANTIQUING AGENTS

Brilliant, shiny and new isn't always all that appealing. Antiquing agents efficiently (and easily) cut the shine, add texture and sometimes even add a bit of dimension to metal. Although there are many antiquing solutions available, for the projects in the book we will be using liver of sulfur and Jax Pewter Black. Keep in mind that you are working with chemicals. I have bowls dedicated solely to this purpose. It never hurts to wear protective gloves (and safety glasses, if you're a splasher!).

BRADS, EYELETS AND SCREWS

Whether you are working with paper or metal, brads, eyelets and micro screws are effective fasteners. When choosing a connector, keep the overall thickness and end result in mind.

If making jewelry and bending wire is something that interests you, some special tools are required. They aren't too terribly expensive and, with the right care and choices, they are a one-time investment that will pay you back many times over.

PLIERS PACK

The majority of projects in this book require at least two, if not all four of the tools here, so when you see *pliers pack* listed in the materials lists, you'll know to have the following at hand.

WIRE CUTTERS: The type of wire and end finish you desire will determine the style of cutter you will use. If you are making jump rings, a flush cutter comes in handy. If you are cutting baling wire, use a beefier pair of cutters.

ROUND-NOSE PLIERS: The most commonly used pliers in this book, these are essential for making loops and smooth curves in wire.

NEEDLE-NOSE PLIERS: These pliers have a grooved grip to the jaws to securely hold wire.

CHAIN-NOSE PLIERS: I commonly use these to open and close jump rings. They are smooth on the inside and will not mar your wire.

FLAT-NOSE PLIERS: These are similar to needle-nose, but the jaws are smooth, so they won't mar the wire.

JEWELRY-MAKING NECESSITIES

SANDPAPER AND METAL FILES: I put files and sandpaper in the same category. Whether working with metal, wood or paint, they both remove excess material. Choose the sandpaper or file that works best for the desired finish. I suggest having a variety on hand. Hardware stores sell variety packs of both. A good standby file is a bastard file. I like using sanding sponges to polish annealed wire, while a finer grade of wet/dry sandpaper works nicely to polish copper that has been etched.

HAMMER AND RUBBER MALLET: Hammers come in all shapes, sizes and materials. If you want to flatten metal without distressing or marring the surface, choose a rubber or rawhide mallet. If you want to add texture or stretch metal, try using a steel hammer. The same goes for hammering wire, though hard wire is a bit easier to flatten with a regular hammer, rather than a mallet.

STEEL BLOCK: A steel block is the perfect tool for flattening metal and wire. If you plan on doing any metal stamping, shaping or wirework, you will need a steel block to support your work. I have tried cheating by hammering directly on top of my worktable. Trust me on this one: It doesn't work. To cut down on the noise and vibration a bit, place your block on a self-healing cutting mat.

DOWELS (³⁄₁₆", ¼", ¾" [5mm, 6mm, 19mm]): Wrapping wire around a wooden dowel serves two purposes: the making of jump rings, and the creation of decorative coils. Wood dowels are very inexpensive and come in a variety of sizes.

BENCH VISE: A bench vise is like another set of hands. It holds your work firmly in place. Many styles are available, but for the projects in this book a small table-clamp style works best. Mine has a permanent home at the end of my worktable. To protect your project from getting marred by the vise, use a soft cloth between the work and the clamp jaws.

AWL OR METAL SCRIBE: An awl and metal scribe can be used to mark your design in metal and to make dimples in your metal prior to drilling. (A needle tool is similar in shape but not as strong and has a finer tip. It works best for piercing paper.)

DRILL AND ASSORTED BITS (¹⁄₁₆", ⅛", ³⁄₁₆", ¼" [2mm, 3mm, 5mm, 6mm]): For those of you who want to experiment without the commitment of buying new tools, I suggest you use a household drill. All of the projects in this book were made with a handheld cordless drill. Once you see how much fun power tools can be and the endless wearable creations you can make, try upgrading to a flex-shaft drill. Another alternative is a Dremel tool. The smaller size of the Dremel is a desirable attribute. There is a multitude of drill and accessory bits available. Look at the task on hand and choose your bit accordingly. If you plan to use baling wire, micro screws, mini eyelets or brads in your work, a ¹⁄₁₆" (2mm) drill bit is a must for your tool box.

BENCH PEG AND G-CLAMP: If you are planning to saw metal you will need a bench peg and clamp. This duo consists of a piece of wood with a triangular wedge cut out at one end and a metal clamp that secures the peg to the table.

METAL SHEARS OR TIN SNIPS: What applies to wire cutters holds true for tin snips: Use what works best for the task you are facing. I like to use combi-snips for detailed work. Aviation snips work great for taking apart tins. I have little hands, and finding heavy-duty cutting tools has been a challenge. (Someone out there thinks that lumberjacks are the only ones who cut metal.) Try different sizes until you find one that works best for you.

JEWELER'S SAW AND COPING SAW: A jeweler's saw is a must for your tool box if you wish to make jewelry. It is used to cut out intricate and decorative shapes and windows from sheet metal. The blades come in a variety of sizes, determined by the thickness of metal you are cutting. Numbers 1 and 2/0 blades are good sizes to have on hand. Coping and jeweler's saws are similar in style and design. They both have removable blades that can be passed through a drilled hole in the middle of a piece of wood or metal to cut out an opening. Use a coping saw to cut a ruler down into beads or parts off of found objects—items that might take more of a toll on a jeweler's saw.

OTHER USEFUL ITEMS

SEWING MACHINE: For the projects in this book, a basic machine will do. As you will see, sewing skills are not a necessity. For added sparkle, try using metallic thread.

RUBBER STAMPS: I can't say much about rubber stamps that hasn't already been said. Buy more rubber stamps—you can never have enough.

SCISSORS, ANYWHERE PUNCHES AND PERSONAL PAPER TRIMMERS: Small scissors with sharp tips work best for detailed work. For punching holes in the center of your project or in hard-to-reach places, try using anywhere punches. They come in a variety of sizes and make neat, perfect holes. If you are not comfortable using a blade and straight-edge, a personal paper trimmer is a great alternative. Most have a swing arm ruler, and the surface is marked with standard card sizes.

NEEDLE TOOL: The easiest way to pierce tiny holes in paper is with one of these.

SPONGES AND STENCILS: If you plan on using stencils in your work, cosmetic sponges are a must. They are also great for edging paper. Sequin waste acts as a great stencil to add texture and color to a number of projects. If you can't find it in your area, Stampotique Originals and Invoke Arts offer stamps that mimic the look.

SEWING TRACING WHEEL: The tracing wheel is another one of my favorite tools for adding a continuous dotted line that resembles stitching.

RETRACTABLE PENCIL: A.k.a. the perfect dot maker, one of these helps me make dots with acrylic paint. (Once dipped in paint, the lead will no longer pop out—this will be a dedicated dot-maker!)

LETTER AND PATTERN STAMPS: Metal letter stamps are the easiest way to add text to metal. They come in different sizes. For added interest, try mixing the sizes. Pattern stamps are a quick way to add texture to any design. For a unique look, try mixing different patterns together. Rummage through your tool box; you will be surprised how many things can take on another life. If you want to add a simple line pattern or dashed line, try using a flat-head screwdriver.

folded

just like homemade cake batter that is rich in ingredients and folded together, a handful of techniques and materials are folded together in this section to create cards that are rich with texture, color and depth. Even though my mom was one of the best and most sought-after seamstresses in the Phoenix Valley, her sewing skills never seemed to rub off on me. I couldn't sew in a zipper to save my life, let alone a buttonhole. So Mom still does my alterations, but I have progressed to sewing paper, though not always in a straight line. The following projects use a variety of basic stamping techniques, wire bending and sewing. You will also be introduced to a simplified, straightforward silk-screening process. Now that takes the cake!

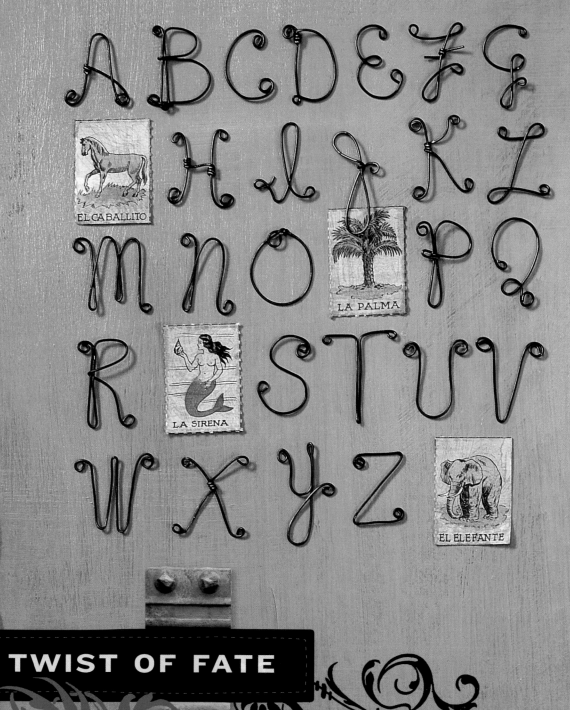

ABCDEFG
HIJKL
MNOP
RSTUV
WXYZ

EL CABALLITO

LA PALMA

LA SIRENA

EL ELEFANTE

TWIST OF FATE

One common way to add text to a card is by stamping something on it. Been there, done that? Here's a chance to create your own font and express your unique personality, using wire. Think of it as an expansion of your signature. While there are several different gauges and colors of wire available, I've found that 20-gauge wire is large enough to be seen easily, yet still bendable enough to work with.

MATERIAL POSSESSIONS

★★★

- 20-gauge annealed wire
- scratch paper
- pencil
- pliers pack (see page 10)

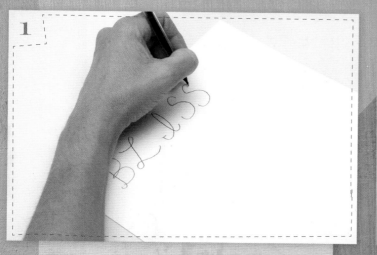

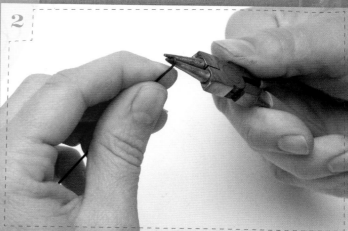

1 WRITE OUT LETTERS

Begin by writing out your letters or numbers on a piece of paper. (I recommend creating your own font, but if you like, you can use the template on pages 120-121, instead of writing out your own.) You can use a ruler to get all of the letters the same height, but I usually just eyeball it.

2 MAKE A LOOP AT ONE END OF WIRE

Cut about 8" (20cm) from the spool of wire, and, with round-nose pliers, create a tiny circle at one end.

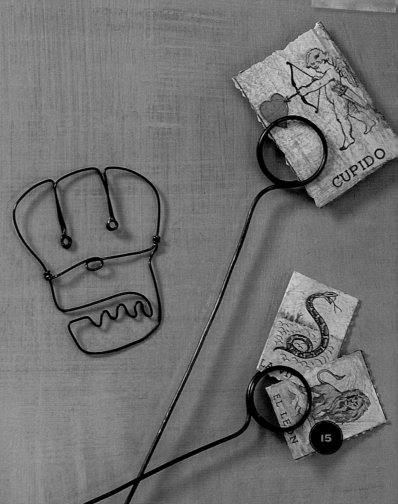

15

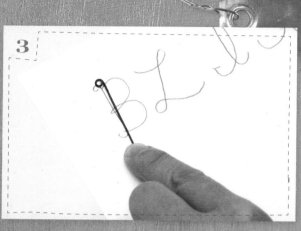

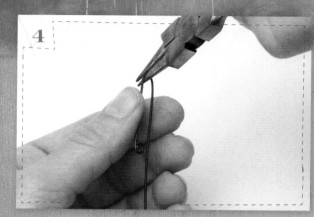

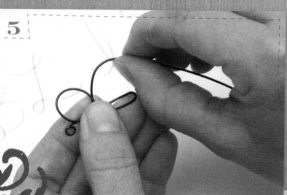

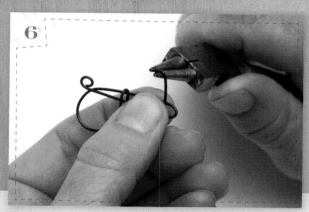

3 HOLD WIRE TO PAPER

Hold the wire down on the paper to make a mental note of where you need to make your first bend.

4 MAKE FIRST BEND

Create a bend in the wire at that point.

5 CREATE CURVES WHERE APPROPRIATE

Using the paper template as a visual guide, make curves in the wire, using your fingers.

6 CREATE FINAL LOOP

When you are done with the letter, trim the excess wire, leaving about ½" (13mm), and create a final loop with the pliers. Most letters can be made with one piece of wire, but an X and a K work best as two pieces.

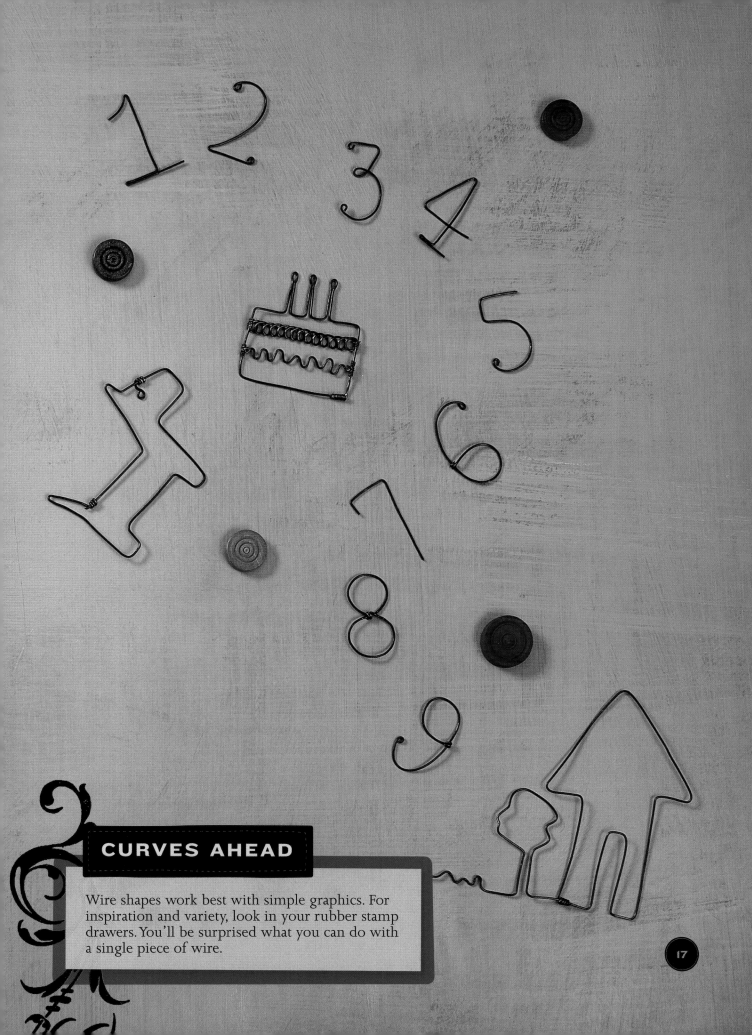

CURVES AHEAD

Wire shapes work best with simple graphics. For inspiration and variety, look in your rubber stamp drawers. You'll be surprised what you can do with a single piece of wire.

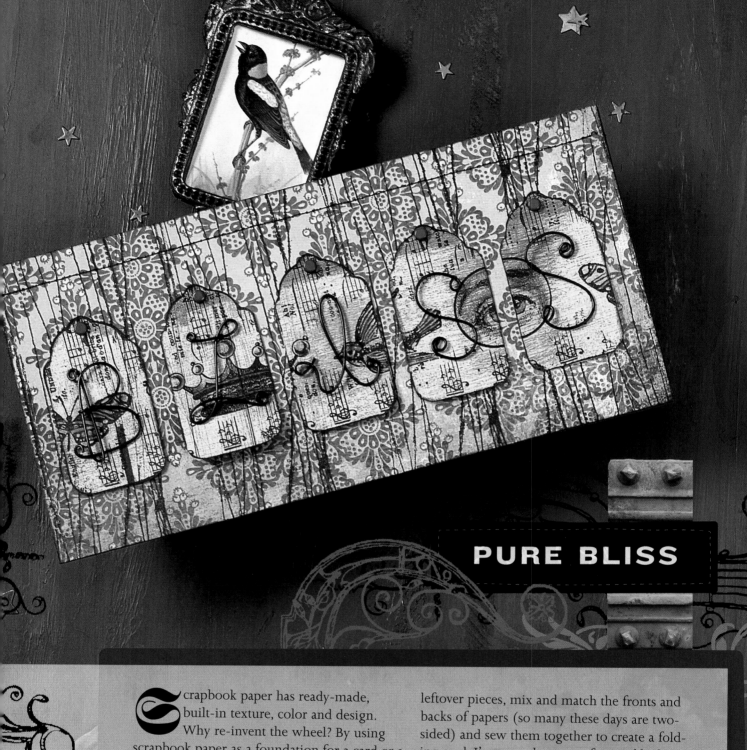

PURE BLISS

Scrapbook paper has ready-made, built-in texture, color and design. Why re-invent the wheel? By using scrapbook paper as a foundation for a card or a piece of art, you can build from there and give old stamps new life while recycling tried-and-true stamping techniques. To recycle smaller, leftover pieces, mix and match the fronts and backs of papers (so many these days are two-sided) and sew them together to create a folding card. I've never been one for sparkle, but since my first encounter with a clear iridescent gel pen, I am all about the shimmer.

MATERIAL POSSESSIONS

- **wire letters to spell BLISS** (see page 14)
- **scrapbook papers:** Aged and Confused, Cinnamon Stripe (Basic Grey, Sublime Collection), Blush (Basic Grey, Devotion Collection)
- **plain paper**
- **cardstock**
- **Palette inkpad:** Noir (Stewart Superior)
- **watercolor pencils and detail watercolor brush**
- **iridescent gel pen:** clear (Sakura)
- **rubber stamps:** Folded Tag (Stampotique Originals), Scratches (Stampers Anonymous), Little bird (Stampotique), Crown (Moon Rose Art Stamps, D420), Eye (Moon Rose Art Stamps, C238), Nose/mouth (Moon Rose Art Stamps, C241)
- **cosmetic sponge**
- **brads**
- **craft glue**
- **double-sided tape**
- **scissors**

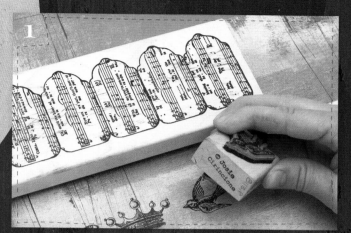

1 STAMP SMALL IMAGES
Pick several small stamps that will fit within the length of the tag stamp and, using the tag stamp as a visual guide, stamp the small images in a line on the scrapbook paper.

2 CUT OUT MASKS
Now, stamp all of the same images on a plain piece of paper, and cut them out to use as masks over the images on the scrapbook paper.

3 STAMP OVER MASKED IMAGES
Using tiny pieces of double-sided tape, adhere the masks over the images. Ink up the tag stamp and stamp it over the masked images.

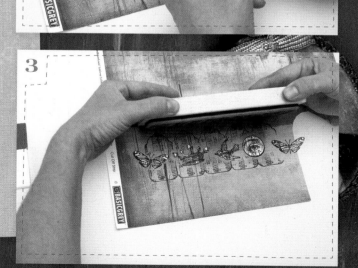

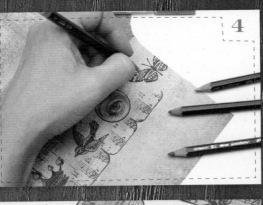

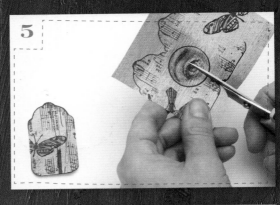

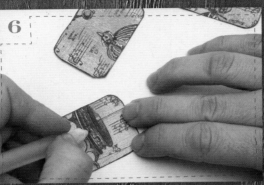

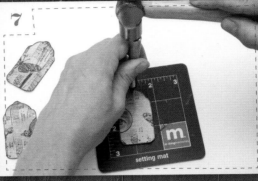

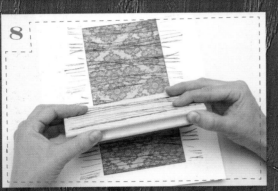

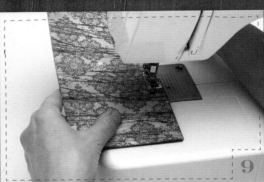

4 ADD SOME COLOR
Remove the masks, and then use watercolor pencil to add some color to the individual images, as you see fit.

5 CUT OUT TAGS
Blend the colors together with a brush and a small amount of water. Cut out each of the individual tags.

6 ADD HIGHLIGHTS WITH PEN
Using a cosmetic sponge, ink the edges of all of the tags with the Noir ink. Add highlights to some of the areas with the gel pen. One easy thing to do is to simply trace over lines from the stamped images.

7 PUNCH HOLES IN TAGS
Punch holes at the top of the tags, using a 1/16" (2mm) hole punch. I usually start with one tag, and then use it as a template for the remaining tags to get them all consistent.

8 STAMP A BACKGROUND
Cut out a new piece of patterned paper that will accommodate your row of tags. Ink the edges with black ink, using the sponge. Create some additional interest across the background using the scratches stamp.

9 SEW BACKGROUND TO CARDSTOCK
Adhere the tags to the background using a small amount of double-sided tape. I like to start with the center tag and then work my way out to make placement easier. Punch holes through the background paper at the holes on the tags, using an anywhere punch. Then, remove the tags and set them aside. Cut a piece of cardstock to the same size as the background, and use a sewing machine to sew the pieces together, along the top of the card.

10 SECURE TAGS WITH BRADS

Put a spot of glue on the back of the cardstock to secure the stitches. Secure the tags to the stitched background with brads, going through the holes made in the last step.

11 ADHERE WIRE LETTERS

Add some highlights to the background paper using the gel pen. Use a piece of scrap paper to dab a bit of craft glue onto the backs of the letters at areas that you know are going to rest on the paper, and adhere them to the tags to finish.

BIRD ON A WIRE

On this card, sewing is used to mimic telephone wires and the stamped tag creates a picket fence.

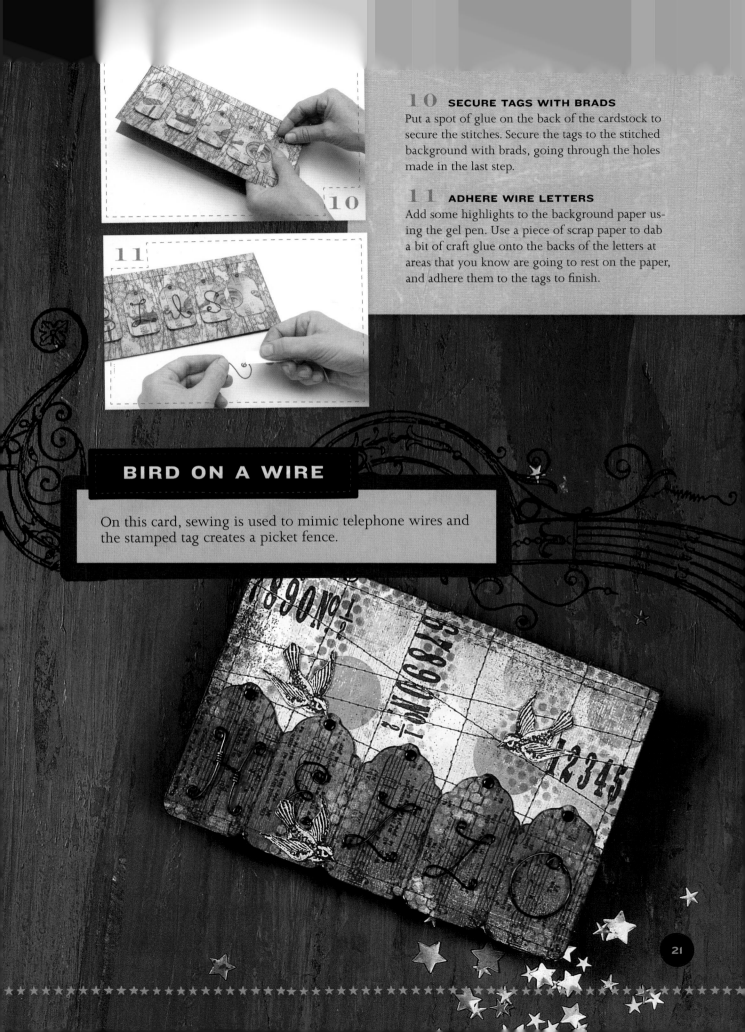

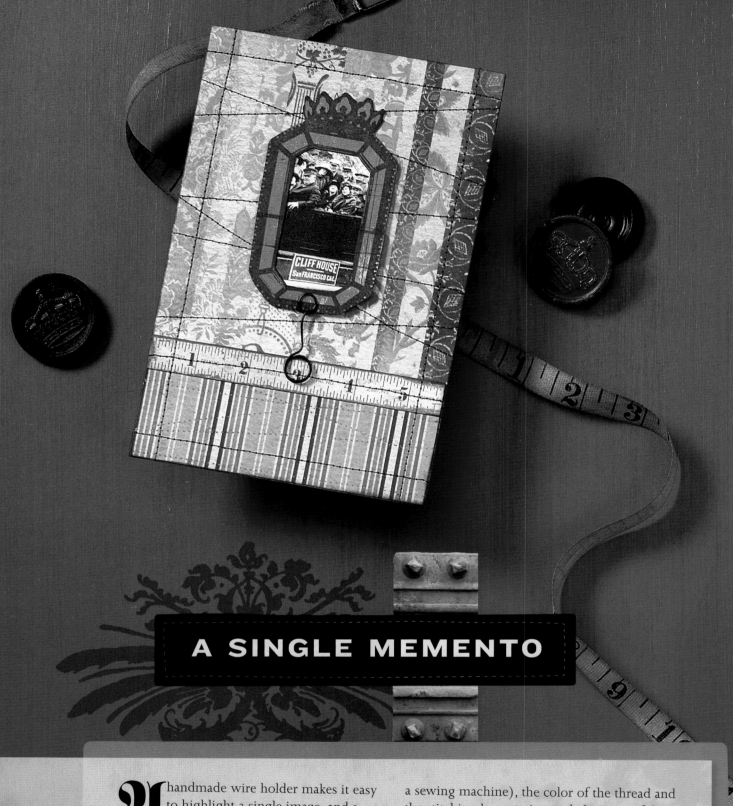

A SINGLE MEMENTO

A handmade wire holder makes it easy to highlight a single image, and a sewing wheel and paint make it easy to create the appearance of stitches. By seaming the card together with real stitches (using a sewing machine), the color of the thread and the stitching become integral elements of the piece. Finally, adding a separate band of paper across the bottom makes for a quick 'n easy pocket.

MATERIAL POSSESSIONS

* 20-gauge annealed wire
* scrapbook papers: Aged and Confused, Cinnamon Stripe (Basic Grey, Sublime Collection), Beneto (7 Gypsies), Rhinebeck (7 Gypsies), Rulers (Design Originals, Distressables)
* cardstock
* image for frame
* Palette inkpads: Noir (Stewart Superior), Burnt Umber (Stewart Superior)
* acrylic craft paint: teal
* frame stamp: Nicho Frames (Invoke Arts)
* cosmetic sponge
* glue stick
* sewing tracing wheel
* detail scissors
* sewing machine
* pliers pack (see page 10)

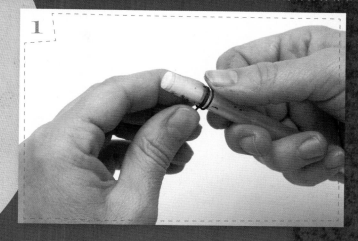

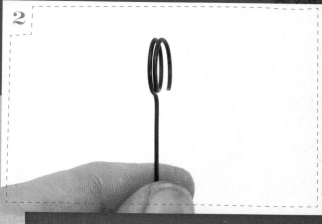

1 WRAP ONE END OF WIRE
Cut a 5" (13cm) length of wire and wrap the end around a pen three times.

2 LEAVE TWO LOOPS
Bend the wire back and trim the loop end to leave two loops.

3 CREATE TWO SMALLER LOOPS
Leave about 1" (3cm) of the wire straight and use a smaller object or dowel to create three loops at the other end. Trim the looped wire to leave two loops at that end as well.

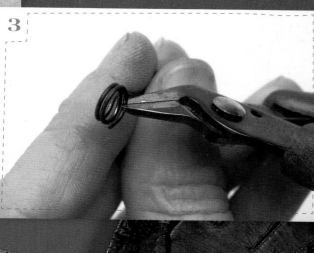

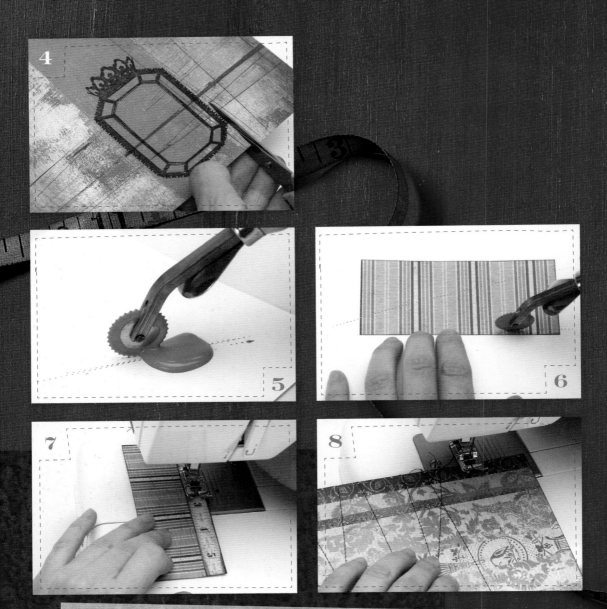

4 CUT OUT FRAME

Stamp the frame stamp onto a solid section of color on a piece of scrapbook paper, then cut it out using scissors.

5 LOAD TRACING WHEEL WITH PAINT

Ink the edges of the frame with the Noir ink, using a cosmetic sponge. Cut a piece of paper for the background, one larger for the upper portion and a narrower strip for the lower portion of the background, and ink the edges of both with Burnt Umber ink. Cut a strip of ruler from the Rulers paper and ink the edges of it with Burnt Umber ink as well. Squirt a small amount of paint onto some scratch paper and load the tracing wheel by running it through the paint a couple of times.

6 ROLL WHEEL OVER PAPER

Run the wheel over the lower background paper. Run the wheel in one direction only.

7 SEW ON RULER PAPER

Adhere the ruler strip to the lower portion of background paper, using small pieces of double-sided tape. Then, sew the ruler strip to the paper, using a sewing machine. Secure the thread on the back with a dab of glue.

8 SEW ON BACKGROUND TEXTURE

Sew random stitching on the larger piece of background paper, using the sewing machine.

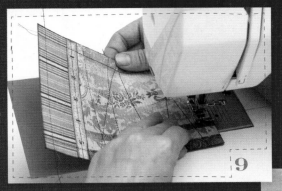

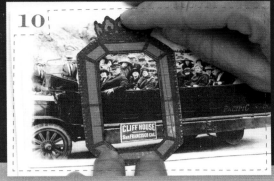

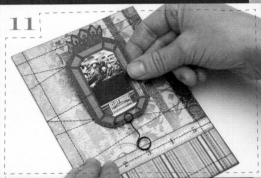

9 SEW CARD PIECES TOGETHER

Using a small amount of double-sided tape, secure the lower portion to the larger portion of paper, and then sew a line around two sides and the bottom. When sewing along the top, add a piece of cardstock trimmed to the same size as the backgrounds.

10 CROP IMAGE WITH FRAME

Hold the frame on a photo, positioning it over that portion you wish to use.

11 SECURE PHOTO IN HOLDER

Glue the frame to the photo, then use scissors to trim it down to match the frame size. Set the frame into the photo holder, and secure the holder to the ruler strip along the bottom of the card.

TRIPLE THREAT

Wire holders are the perfect tools to tell a story in sequence. To tie three pictures together, add a similar visual element to each one.

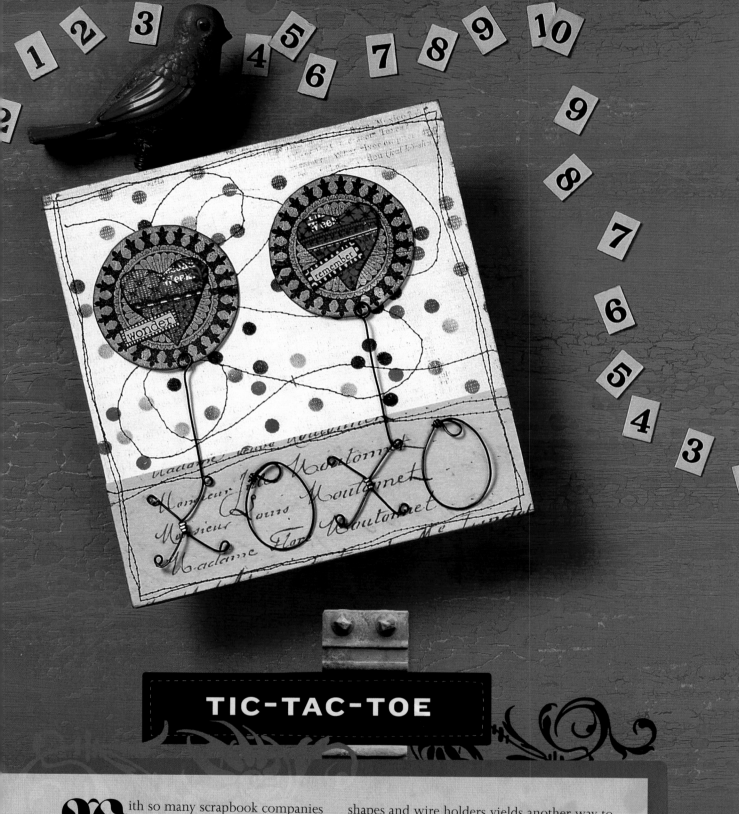

TIC-TAC-TOE

With so many scrapbook companies to choose from, pulling papers from a variety of brands and styles helps you develop your own diverse color palette. In the same way, combining letters, shapes and wire holders yields another way to highlight a single image and convey a sentiment at the same time.

MATERIAL POSSESSIONS

- 20-gauge annealed wire
- scrapbook papers: Aged and Confused, Live Play (Basic Grey, Sublime Collection), Railway Journal (Daisy D's), Colonial Dot Parchment (Daisy D's), Brompton (7 Gypsies)
- cardstock
- Palette inkpads: Noir (Stewart Superior), Burnt Umber (Stewart Superior)
- rubber stamps: Funky Hearts (Invoke Arts), Tres Santos (Invoke Arts)
- cosmetic sponge
- glue stick
- double-sided tape
- detail scissors
- sewing machine
- pliers pack (see page 10)
- hammer and metal block

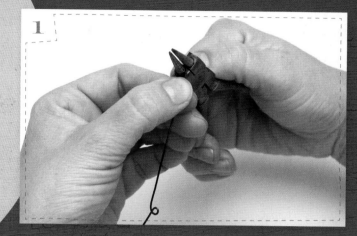

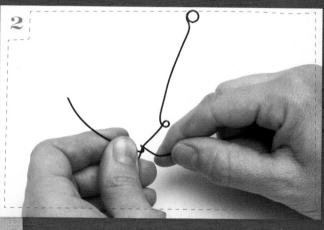

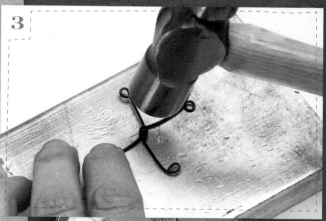

1 CREATE ONE HALF OF LETTER

For this card, we will make two Xs (which will also be photo holders) and two Os. Draw one of each of these letters on paper. Begin by cutting a length of wire to about 12" (30cm). Create a tiny circle on one end for one side of an X. Leave some straight wire for the height of the letter. Create a second loop at what will be the top of the letter, and then leave about 1½" (4cm) for a photo holder before trimming the wire.

2 WRAP SECOND HALF OF LETTER

For the top of the photo holder, wrap the wire three times in a loop, and then trim to leave two loops for the photo holder. Cut a new length of wire to about 4" (10cm). With it centered on the X portion of one photo holder piece, wrap it three or four times around, getting it situated how you want it.

3 HAMMER LETTER FLAT

Trim the ends to be just slightly longer than the other half of the X, so that you can create circles on the ends. Hammer the wrapped portion on a metal block, then repeat for the other photo holder. Create two Os as well.

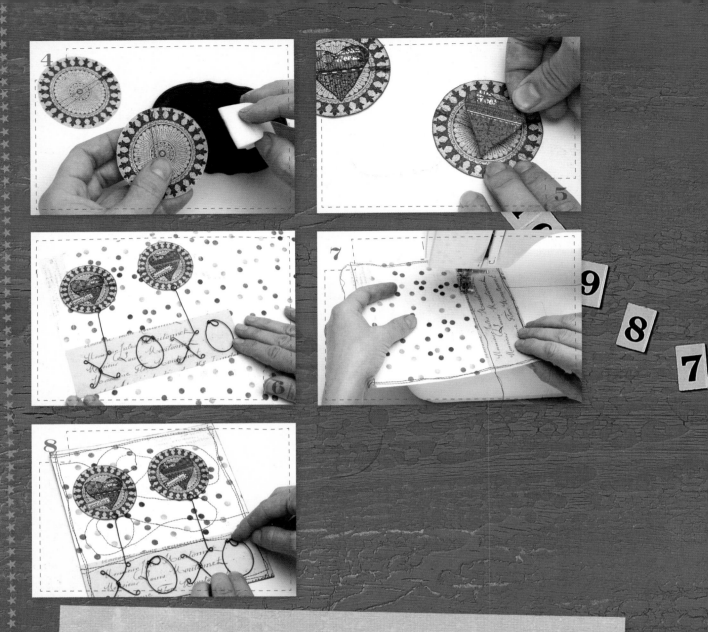

4 PREPARE CIRCLE SHAPES

Stamp with the circle stamp onto the Live Play paper twice, and cut out the shapes. Ink the circle's edges using Burnt Umber ink and a cosmetic sponge.

5 ADHERE HEARTS TO CIRCLES

Stamp the heart stamp onto the Railway Journal paper twice, and cut out the shapes. Ink the edges with Burnt Umber as well. Glue the hearts to the centers of the circle shapes.

6 TRIM BACKGROUND PAPERS

Using Noir ink, stamp the two text stamps (from the heart stamp) onto a portion of the Brompton paper, cut them out and glue one to the center of each heart. Insert the circles into the photo holders. Lay out your Xs and Os over a portion of the Brompton paper to decide how large of a piece to cut, and then trim a section for the lower half of the background.

Next, lay the trimmed paper and the letters over the dot paper to estimate its size.

7 SEW AROUND BACKGROUND

Cut the dot paper to the correct size. Adhere the lower portion of paper over the dot paper with a small amount of double-sided tape. Then, use the sewing machine to sew a couple of lines around the outside of the entire piece. Also sew lines along the top of the smaller piece of paper.

8 ATTACH LETTERS

To the dot portion of the background, add some random stitching for added interest. Cut a piece of cardstock to the same size as the background piece and secure the two together by sewing along the top. Glue the letters to the lower portion of the card to finish.

TRUST YOUR LUCK

Mixing fonts and materials is another way to add interest and make your words stand out.

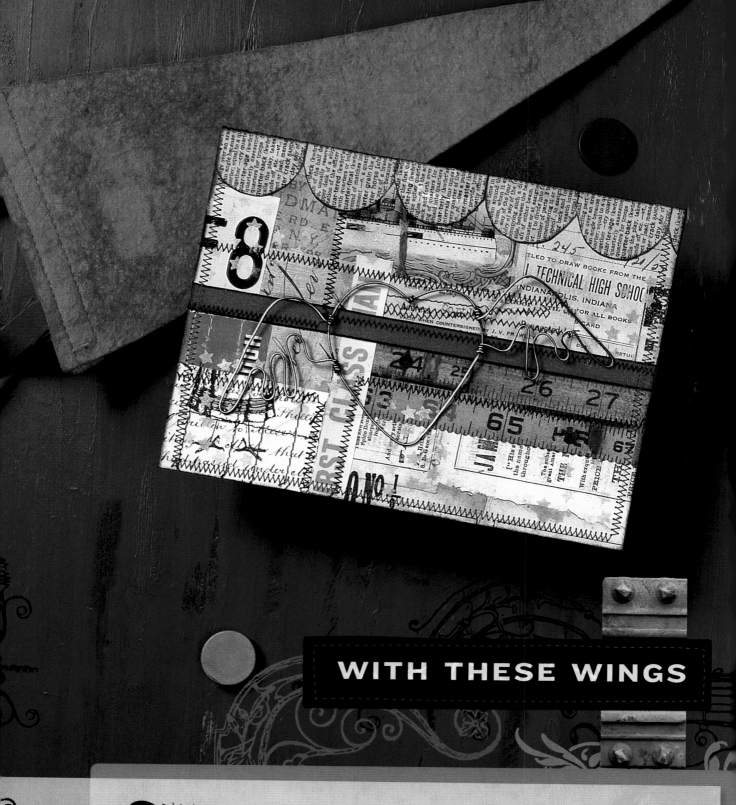

This is a great way to recycle what I like to call "bitlets" (small, leftover pieces) of paper and salvage scraps from experiments gone wrong. With the popularity of simple line-drawing stamps making a comeback, try to sketch your own simple design and give it dimension with wire. While I've stuck with annealed wire, consider using colored wires as you would inkpad colors. The white interior of a card can be blinding, so why not use colored cardstock and seam the card together using a decorative border stamp and your sewing machine. For adding spot color and pattern, create your own stencils if the ready-made variety are not to your liking.

MATERIAL POSSESSIONS

- 20-gauge annealed wire
- scratch paper
- scrapbook paper scraps
- parchment paper
- cardstock
- metallic inkpad: gold (Tsukineko, Encore)
- pencil
- scallop/text stamp (Stampers Anonymous U4-1149)
- cosmetic sponge
- glue stick
- 1/2" (13mm) silk ribbon
- sanding block or sandpaper
- small shape punch (star)
- detail scissors
- sewing machine
- pliers pack (see page 10)

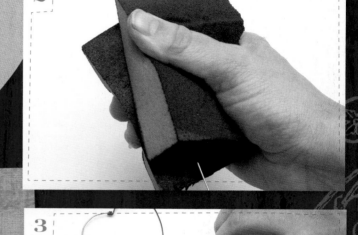

1 SKETCH IMAGE
Sketch out your wire doodle on scratch paper using a pencil, or use the template on page 123.

2 POLISH LENGTH OF WIRE
Cut about a 12" (30cm) length of wire and sand it with either sandpaper or a sanding block to make it shiny.

3 FORM WIRE TO SHAPE
Use the sketch as a guide to shape the wire with your hands or pliers. I started with the heart portion here, then worked on the wings.

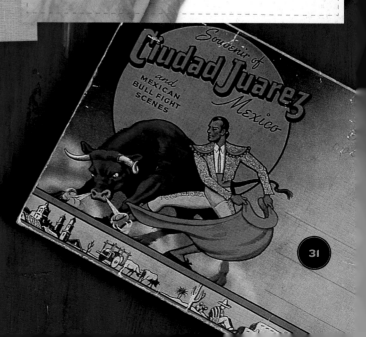

4 SECURE WIRE ENDS

Connect ends together by wrapping the wire. Here, I attached the wings to the heart by wrapping the ends of the wing wire around the heart. Hammer the twisted portions slightly to flatten them.

5 CREATE A PATCHWORK

Cut a piece of cardstock that is large enough to accommodate the wire image. Begin gluing down random pieces of different papers to create a patchwork look.

6 TRIM EXCESS PAPER

When your piece is as covered as you would like it, trim away any excess paper around the edges.

7 SEW ON RIBBON

Glue a piece of ribbon to the piece where you plan on putting the wire image, to help draw the eye there. Use a zigzag stitch with a sewing machine to add some texture over the entire scrap paper piece, using black thread.

8 SEW AROUND OUTSIDE

Add some stitching in a contrasting color around the outside.

9 GLUE ON SCALLOPED HINGE

Trim a piece of cardstock to the same size as the scrap paper piece. Stamp onto a solid color of paper, using a border stamp, such as this scallop. Cut out the border shape using scissors. Glue the scallop shape to the top of the card, letting about half of it hang off the top. Set the scrap paper piece on top of the cardstock. Score the scallop piece at the top of the card and wrap the excess over to the back. Secure with glue.

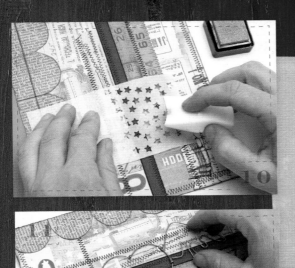

10 DAB ON INK WITH STENCIL

Create a little stencil by punching randomly spaced shapes from a scrap of parchment paper. Use a cosmetic sponge to dab metallic ink over the stencil and onto the card.

11 ADHERE WIRE TO CARD

Glue the wire doodle onto the front of the card.

TRY IT
(you'll like it)

Create a striped look by sewing long strips of paper together.

SHAKEN NOT STIRRED

Try using scraps of colored ribbon to highlight a single element and rubber stamps on scrapbook paper to make your own letter tiles.

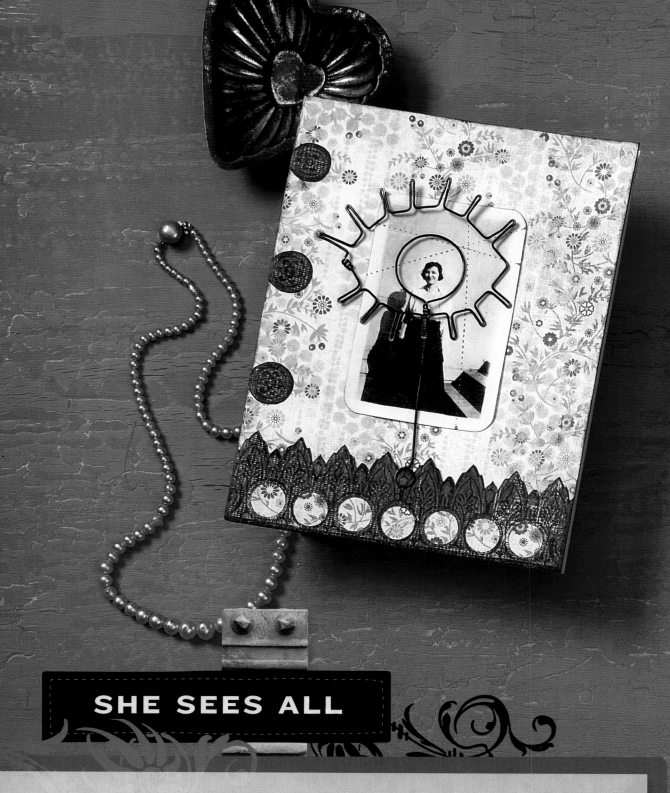

SHE SEES ALL

Think outside the box and bend your own frame into a surprising shape, using wire to accent a focal point on a photograph. Deconstructing the individual elements of a rubber stamp opens up different possibilities and takes you beyond the boundaries of someone else's design ideas. Colored chalks are an easy way to add interest to any black-and-white copy of a photograph.

MATERIAL POSSESSIONS

- 20-gauge annealed wire
- scrapbook papers: Railway Journal (Daisy D's), Blush (Basic Grey, Admire collection)
- cardstock
- vintage portrait, small
- Palette inkpads: Noir (Stewart Superior), Burnt Umber (Stewart Superior)
- metallic inkpad: gold (Tsukineko, Encore)
- blending chalks (Inkadinkado)
- acrylic craft paint: yellow
- Traditional Borders stamp (Invoke Arts)
- cosmetic sponge
- sequin waste
- glue stick
- sewing tracing wheel
- detail scissors
- 1/2" (13mm) circle punch
- pliers pack (see page 10)

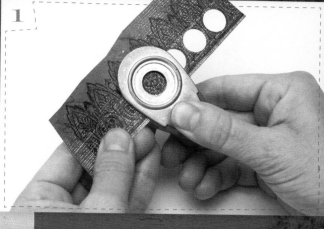

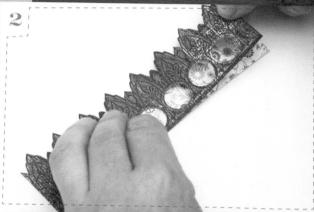

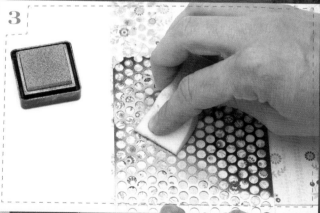

1 PUNCH OUT CIRCLES

Stamp the border stamp onto the Railway Journal paper. Use a 1/2" (13mm) circle punch to punch out the circle portion of the design.

2 TRIM PAPER FOR BORDER

Cut out the border shape, using scissors. Trim two pieces of cardstock to the desired card size (here, I made it the width of the border strip). Cut a strip from the Admire paper to a size the same width as the border and narrow enough that it only shows through the holes.

3 SPONGE INK ONTO BACKGROUND

Cut a second piece of the Admire paper to the same size as the cardstock. Glue the paper to the card-stock. Using a piece of sequin waste as a stencil, sponge on gold metallic ink in a few areas.

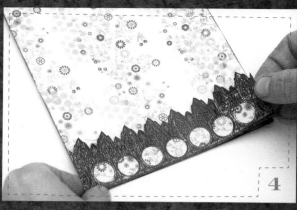

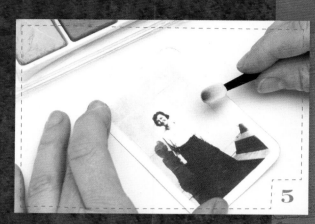

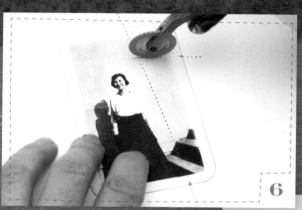

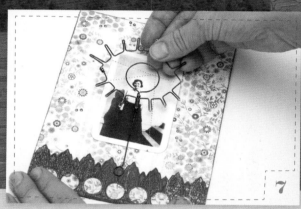

4 ADHERE BORDER TO CARD

Ink the edges of the piece with Burnt Umber, using the sponge. Glue the border piece to the bottom of the card.

5 HAND-TINT PHOTOGRAPH

Apply color to the vintage portrait using blending chalks.

6 ADD FAUX-STITCH TEXTURE

Roll some faux stitches over the portrait using the acrylic paint and the tracing wheel. (See page 24.)

7 ADD AN EYE SHAPE

Create an eye image out of wire (see page 30 for information on making your own wire images, or use the template on page 122), and attach it to a longer piece of wire to act as a photo holder. Stick the wire to the border and position the eye over the face of the portrait, securing it to the card with a bit of glue.

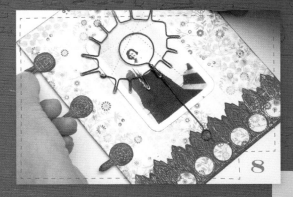

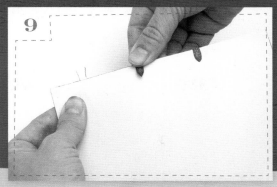

8 GLUE ON PAPER HINGES

Stamp the border stamp on the Railway Journal paper again, and cut out three of the circles with scissors, leaving a tab portion attached to each circle. Glue the circle portion of each to the left side of the card.

9 SECURE HINGES ON CARD BACK

Then fold the tab portions over and glue them to the back, with the second piece of cardstock under the first so that the hinges attach the two together.

THE FORTUNE TELLER

Use the shape of a wire frame to tell the story within a picture. Remember, you're not limited to a single piece of wire; simply twist one piece onto the other.

AMORE

DANGEROUS beautiful

CELEBRITY news

a new outlook on life,

SIGNED AND SEALED

on't let standard-size envelopes seal you in. The wrapping can be as important as the message inside. Make a great first impression by creating your own envelopes using recycled pages from vintage magazines. When using old magazines, make sure the pages aren't dry and crispy. (They will tear at the first fold.) For larger cards try using atlases; the oversized pages easily accommodate odd-sized cards. Whichever size you make, the most important step in this project is the addition of the cardstock lining.

MATERIAL POSSESSIONS

- vintage magazine
- cardstock
- glue stick
- cutting mat
- ruler
- craft knife
- $1/8"$ (3mm) eyelets, hole punch and setter
- corner punch
- small tag punch

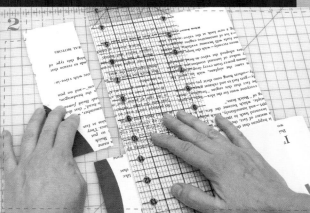

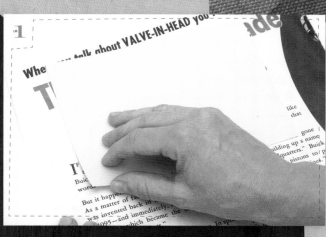

1 ADHERE CARDSTOCK TO PAPER
Cut a piece of cardstock about $1/4"$ (6mm) larger than your card on each side. Glue the cardstock to the back of the magazine page you wish to use, centering it over the reverse side of the area that you plan to be the front.

2 NOTCH CORNERS
Position the ruler at the edges of the cardstock and, using a craft knife, cut at 90-degree angles to notch the corners.

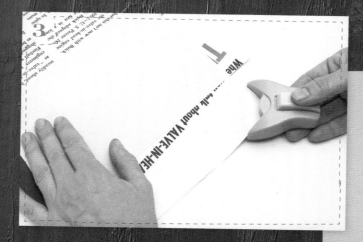

3 ROUND CORNERS
Use the corner punch to round all of the corners.

4 SECURE ADDRESS TAGS
Fold the sides in, folding the largest portion in half, if necessary. Cut two tags out of cardstock, using the tag punch. Glue the tags to the front of the envelope, where you want the mailing and return addresses to go. Punch holes in the tags and set eyelets in them.

5 GLUE BOTTOM FLAP TO SIDES
Apply glue to the edges of the bottom flap and secure it to the sides. The envelope is ready to stuff and mail.

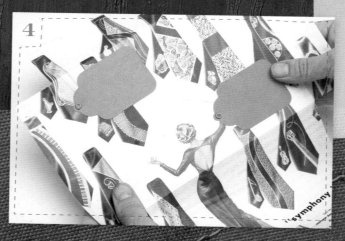

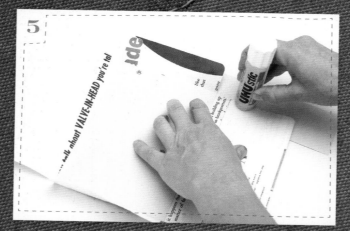

SECRETS ON THE INSIDE

Shipping labels do not need to take away from the stunning images, and it's easy to create a theme for a set, using pages from the same magazine.

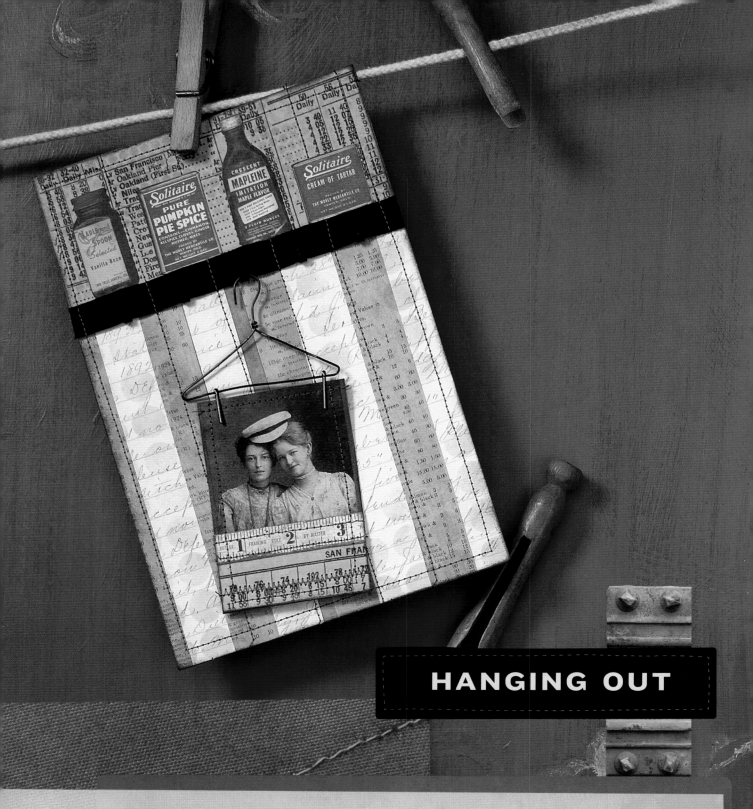

HANGING OUT

While walking down the aisle at the hardware store, I spied a drawer labeled "cotter pins." Of course, the first thing that came to my mind was the theme song, "Welcome back. The dreams are yours, take them back . . ." I had to stop and look. Here, simple hardware store cotter pins take on a new life as clothespins and hangers to suspend featured elements. In a similar fashion, hook and eye tape (hook only) takes on a life of Shaker-peg molding. Use leftover sequin scrim to stencil different circles and colors on your paper.

MATERIAL POSSESSIONS

- 20-gauge annealed wire
- scrapbook papers: striped ledger paper (Foofala), Rulers (Design Originals), What's Cookin' (Design Originals), Train Schedule (Rusty Pickle)
- cardstock
- vintage photocopy
- Palette inkpads: Burnt Umber (Stewart Superior), Ballet Blue (Stewart Superior)
- cosmetic sponge
- double-sided tape
- glue stick
- hook and eye tape
- cotter pins
- sequin waste
- sewing machine
- pliers pack (see page 10)

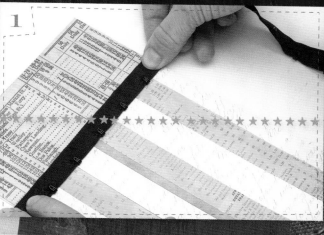

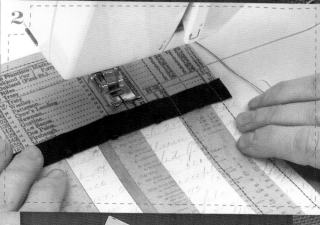

1 SECURE BACKGROUND PAPERS

Cut a piece of the Train Schedule paper to serve as the upper portion of the background and glue it to a trimmed piece of cardstock. Cut a piece of the striped ledger paper for the larger, lower portion of the background and glue it to the cardstock as well. Cut a length of the hook portion of the tape, slightly longer than the width of the card, and adhere it at the paper seam, using double-sided tape.

2 ADD STITCHING

Sew a series of vertical lines down the piece. Sew a line around the sides and bottom, and then attach a second piece of cardstock by sewing along the top.

3 STITCH A PHOTO PIECE

Mount your photo onto a piece of cardstock, then add a strip of the Train Schedule paper and a strip of ruler from the Rulers paper to the bottom of the photo. Trim the excess, then sew some lines around the photo piece, using a sewing machine.

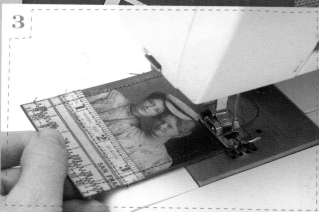

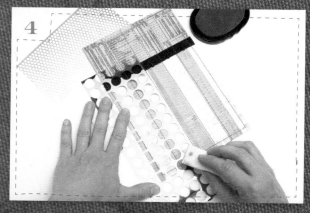

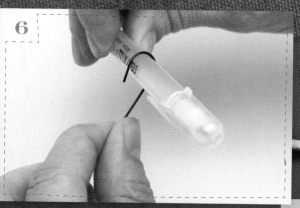

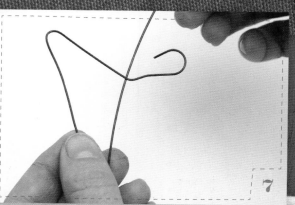

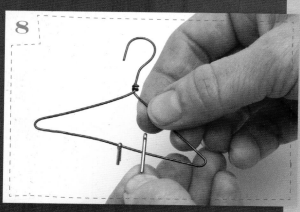

4 APPLY DOTS WITH INK AND STENCIL

Cut a piece of sequin waste to use as a stencil, and pounce Ballet Blue ink onto sections of the card. Sometimes it's fun to use more than one size.

5 ADHERE ROW OF JARS

Use a sponge to dab Burnt Umber onto the edges of the card. Cut out a few spice jars and bottles from the What's Cookin' paper and adhere them at the top edge of the tape.

6 BEND WIRE FOR HOOK

To create a cute clothes hanger, cut about 12" (30cm) of wire and straighten it out as best you can. Wrap one end around a pen to create the hook.

7 CREATE HANGER SHAPE

Bend the wire to create a basic hanger shape. (If you like, you may use the template on page 122.)

8 ATTACH COTTER PINS

Then wrap the end around the base of the hook about three times and trim the excess. Attach two cotter pins to the hanger.

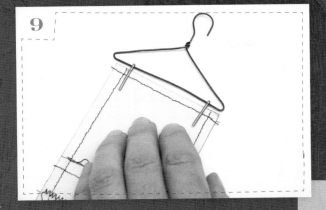

9 **SECURE PHOTO TO PINS**

Slide the photo piece into the cotter pins, and then, add some glue on the back of the photo to reinforce the hold. Let the glue dry.

10 **HANG PHOTO ON TAPE**

Hang the hanger on the hook tape to finish.

DIRTY LAUNDRY

Cotter pins are a great way to display a single image or a series. I also like using them to display letter tiles.

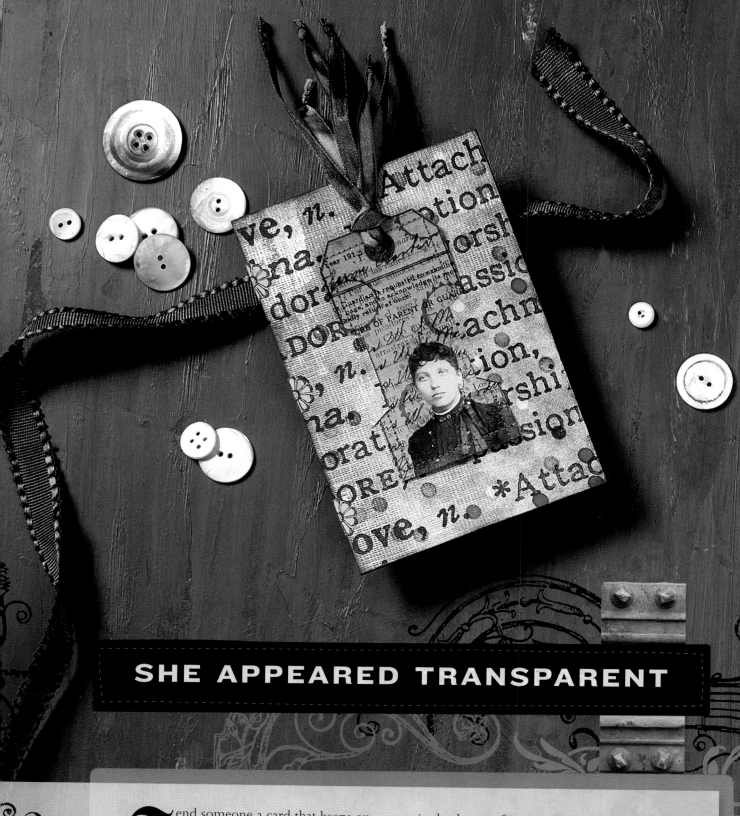

SHE APPEARED TRANSPARENT

 end someone a card that keeps on giving. Here, a card becomes the carrier of an additional treat—a removable bookmark. You can use a simple slit method as the bookmark holder, or pick a single element from a rubber stamp to fashion tabs. My stipple tool of choice, a retractable pencil, amuses many when it appears from my toolbag, but take my word for it—it makes perfect little dots.

MATERIAL POSSESSIONS

- Colonial Dot Blue paper (Daisy D's, Moda Collection)
- gold paper
- cardstock
- old textbook paper
- printed transparency
- vintage portrait photocopy
- Palette inkpads: Noir (Stewart Superior), Ballet Blue (Stewart Superior)
- metallic inkpad: gold (Tsukineko, Encore)
- water-soluble oil pastels (Portfolio)
- acrylic craft paint: teal
- pencil
- rubber stamps: Evidence Doll stamp (Invoke Arts), Large Love Definition (Stampotique), Sequin Waste (Stampotique), Daisy Lace (Hero Arts)
- cosmetic sponge
- small paintbrush or retractable pencil
- glue stick
- scissors
- craft knife
- sewing machine

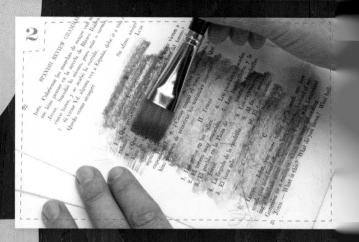

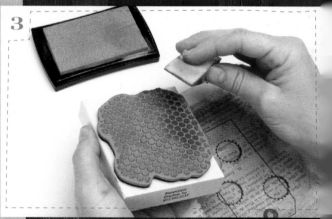

1 APPLY COLOR WITH PASTELS
Lay down some pastel color on the text book paper. Use about three colors.

2 BRUSH ON WATER
Brush water over the pastel to blend the colors and then let the paper dry.

3 INK UP SEQUIN WASTE STAMP
Stamp the tag stamp in Noir ink, over the dry, colored paper. Stamp the circle stamp over the surface as well. Use a cosmetic sponge to randomly ink up the sequin waste stamp.

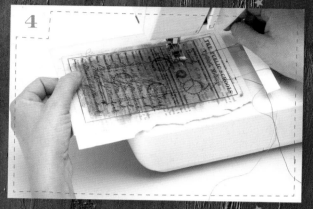

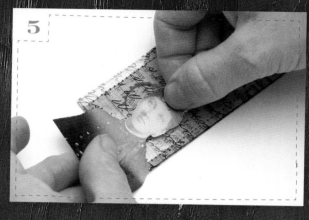

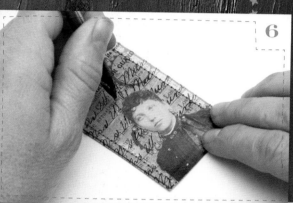

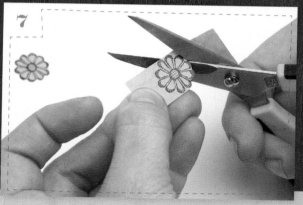

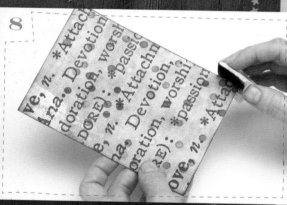

4 SEW TRANSPARENCY TO TAG

Stamp the sequin waste stamp over the tag. Cut a section of printed transparency and using a sewing machine, sew it onto the tag paper.

5 GLUE FIGURE TO TAG

Cut out the tag shape with scissors. Cut out the torso and head from a vintage portrait. Glue the figure onto the tag.

6 ADD DOTS OF PAINT

Add acrylic paint dots around the figure, using the end of the paintbrush or the tip of a retractable pencil.

7 CUT OUT DAISIES

Stamp the daisy stamp in Noir ink onto the gold paper, then cut out the three flowers and set them aside.

8 PREPARE CARD

Cut a piece of scrapbook paper and cardstock to the desired card size, and glue the paper to the cardstock. Cut a second piece of cardstock to the same size and set aside. Stamp the text stamp several times over the card. Ink the edges of the card with Noir ink, using a cosmetic sponge.

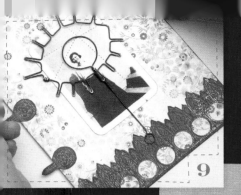

9

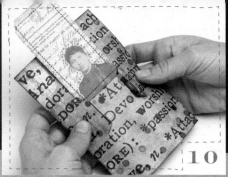

10

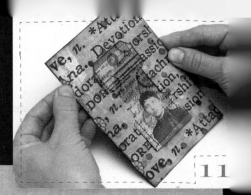

11

9 TRACE TAG ONTO CARD
Center the tag on the card and lightly trace the two sides with a pencil.

10 CREATE FLAPS FOR TAG
Draw two more lines about 1/8" (3mm) outside of the first lines, and then section off about a 2" (5cm) section in the center of the lines. Draw four lines at an angle from the marks to the inside. Score the lines between the marks, and use a craft knife to cut out the angled flaps. Insert the tag into the flaps.

11 ADD HINGES AND RIBBON
Glue the yellow flowers onto the left side of the card, to act as a hinge. Finally, add a ribbon to the top of the tag as a flourish.

SPIDER PARTY

The spiders on this jumbo piece of tag art seem to jump off the card, with heads that are mounted on foam dots.

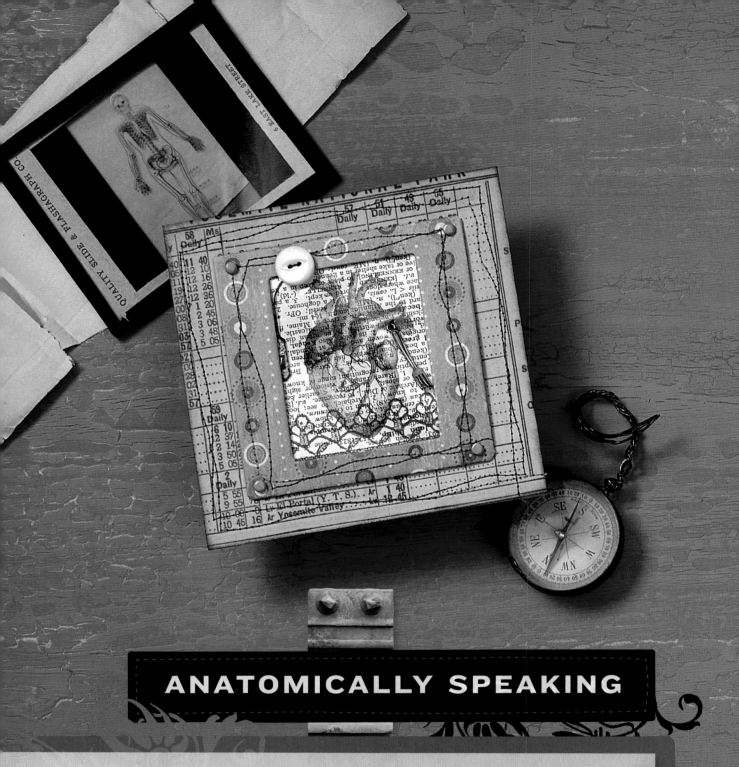

ANATOMICALLY SPEAKING

Clip art and decorative paper can come together strikingly through the modern marvels of photocopy technology. By photocopying clip art onto scrapbook paper or pages of a dictionary, you add instant dimension to any image. Try the same technique with a black-and-white photograph. For a quick 'n easy book idea, make a series of slide mounts and bind them together.

MATERIAL POSSESSIONS

- 28-gauge annealed wire
- scrapbook papers: Circles (K&Company, Kazoo Kits Collection), Train Schedule (Rusty Pickle)
- cardstock
- anatomy clip art
- transparency sheet
- old dictionary page
- large slide mount
- StazOn inkpads: Blazing Red (Tsukineko), Teal Blue (Tsukineko)
- Palette inkpad: Burnt Umber (Stewart Superior)
- pencil
- rubber stamps: Petal Lace (Hero Arts), alphabet stamp
- cosmetic sponge
- small charm brads
- button
- glue stick
- double-sided tape
- wire cutters
- scissors
- needle tool
- sewing machine

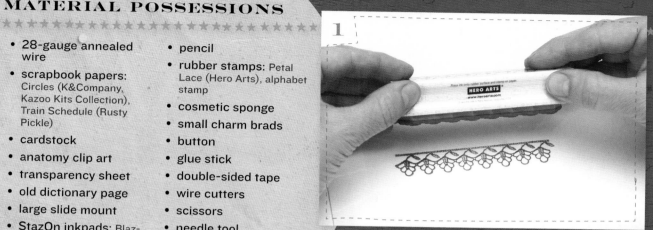

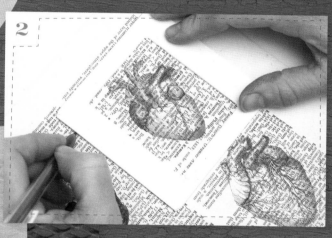

1 STAMP ONTO TRANSPARENCY
Photocopy several anatomy images onto an old dictionary page. Stamp onto a plain transparency with the lace stamp, using red ink. Set aside to dry.

2 TRACE SLIDE MOUNT ONTO PAGE
Open the slide mount and cut it in half. Trace the slide mount onto the dictionary page.

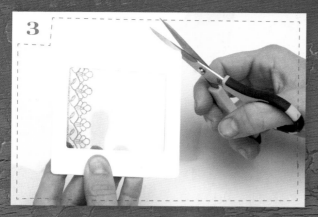

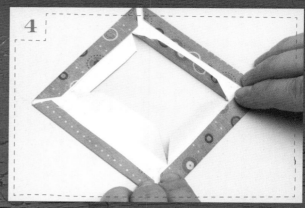

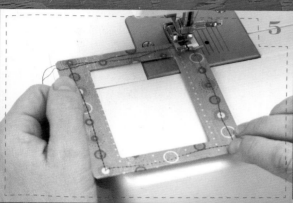

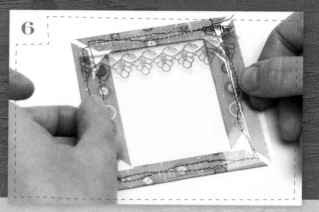

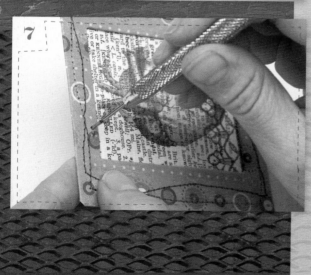

3 TRIM TRANSPARENCY TO SIZE
Cut out the slide shape with scissors. Use the mount as a guide to cut out the stamped transparency as well, positioning the lace along one side of the window.

4 COVER SLIDE MOUNT WITH PAPER
Glue the slide mount to a piece of the Circles paper. Notch the corners, using scissors, and cut an X inside the window, from corner to corner. Apply more glue to the back of the slide mount and wrap the paper around to the back to secure it.

5 ADD DETAIL STITCHING
Sew a couple of lines around the perimeter of the front of the slide mount, using a contrasting color of thread.

6 ADHERE TRANSPARENCY
Put a line of double-sided tape on the back of the slide mount, and adhere the stamped transparency.

7 PUNCH A HOLD FOR BUTTON
Apply a second line of tape on top of the transparency, and adhere the dictionary paper to the back of the transparency. Trim off any excess paper or transparency, if necessary. Use a needle tool to make a couple of holes at the top of the mount where you want a button to go.

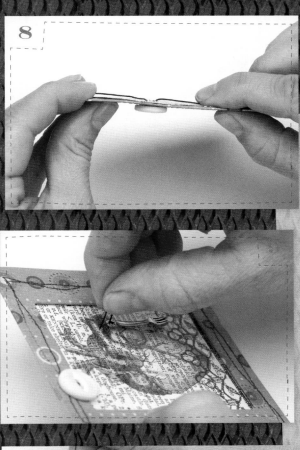

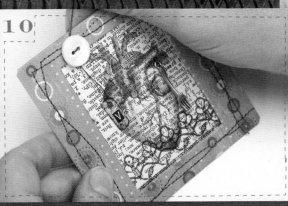

8 ATTACH BUTTON WITH WIRE

Attach the button with a short length of wire, bending the wire flat in the back.

9 ATTACH A SMALL CHARM

Punch two more holes where you want to add a charm, and attach it with wire as you did to secure the button.

10 ADD TAG TO BUTTON

Create a tiny tag and tie a length of thread onto it. Tie the thread onto the button.

11 STAMP A LETTER

Stamp a letter over the heart on the transparency, using a letter stamp and teal ink.

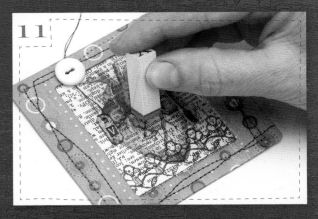

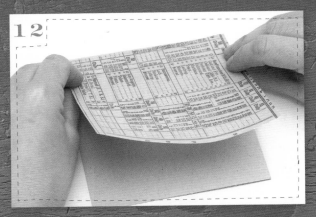

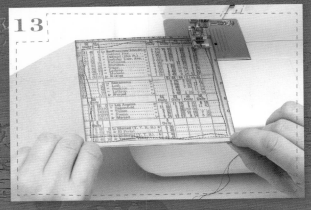

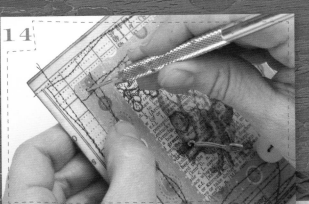

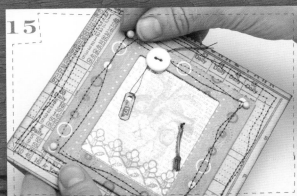

12 FOLD PAPER AND CARDSTOCK FOR CARD
Create a folded card from cardstock that is a bit bigger than the slide mount. Cut a piece of Train Schedule paper the size of the front of the card and glue it to the cardstock.

13 STITCH A BORDER AROUND CARD
Ink the edges of the card with a cosmetic sponge and Burnt Umber ink. Sew a border around the outer portion of the front of the card.

14 PUNCH HOLES IN SLIDE MOUNT CORNERS
Punch holes in the corners of the slide mount, and then glue the mount to the front of the card. Use the needle tool to then punch holes through the card as well.

15 SECURE SLIDE MOUNT WITH BRADS
Add brads to the corners to finish.

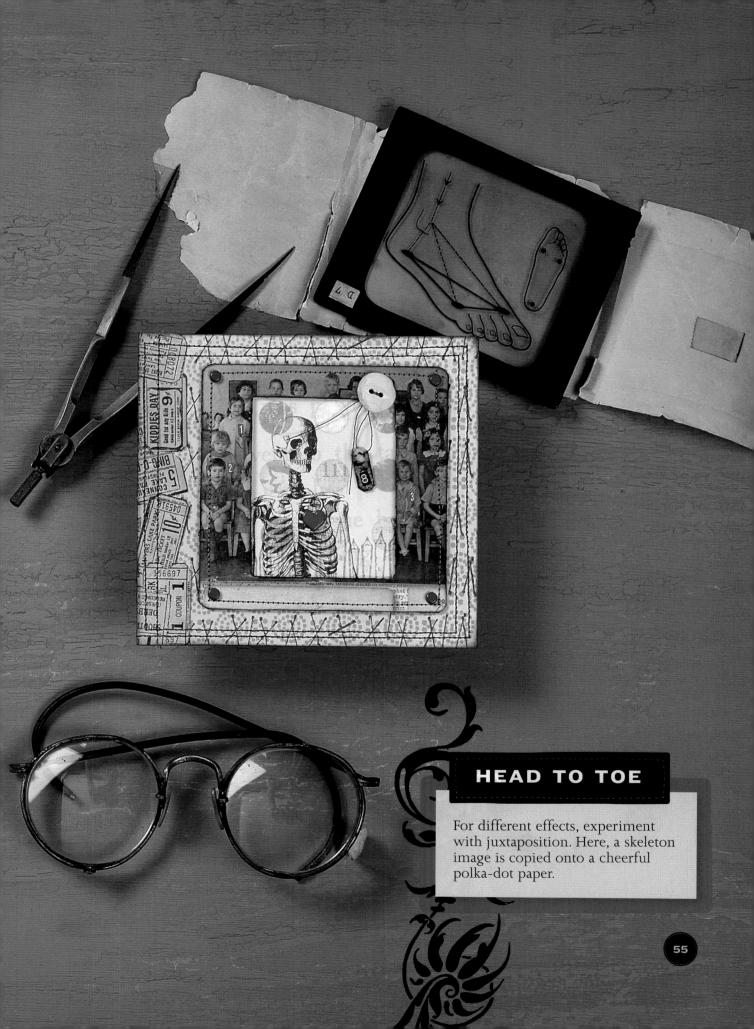

HEAD TO TOE

For different effects, experiment with juxtaposition. Here, a skeleton image is copied onto a cheerful polka-dot paper.

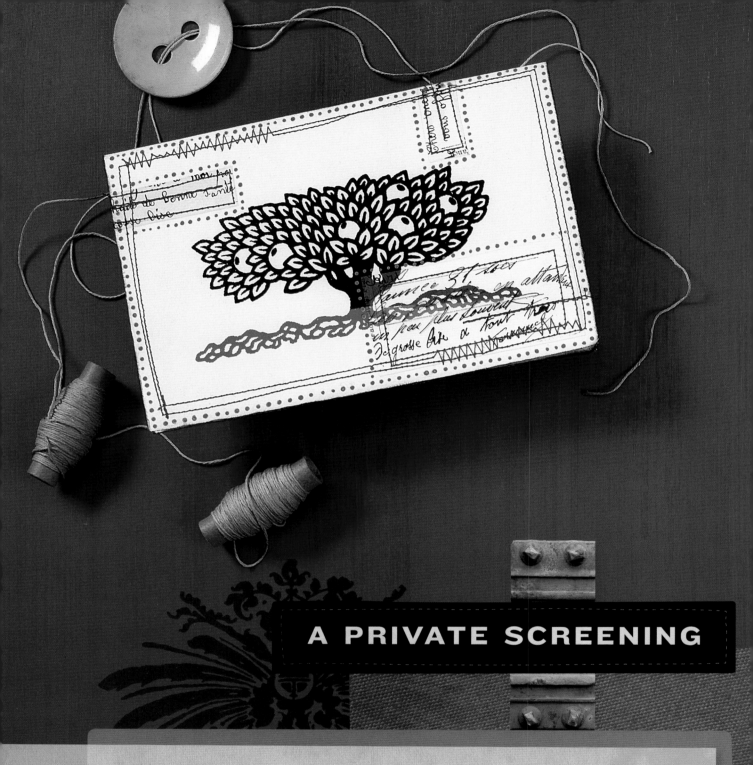

A PRIVATE SCREENING

I wanted to try silk screening for the longest time, but the cost and necessary equipment made me shy away from it. PhotoEZ answers both problems and provides a great alternative to traditional silk screening. This product makes it easy to turn a black-and-white photograph into a high-contrast, graphic image. Once the printing portion is complete, you can embellish your piece with stamping, stitching, paper elements—whatever you desire.

MATERIAL POSSESSIONS

- paper for printing on
- silk screening inks
- PhotoEZ stencil
- stencil adhesive
- palette knife
- squeegee
- heat gun

1 PREPARE STENCIL SCREEN

Create a stencil from your own transparency, using the PhotoEZ material, following the manufacturer's directions. Apply stencil adhesive to the stencil.

2 ADHERE STENCIL SCREEN TO PAPER

Adhere the stencil to paper that you wish to print on. (You can see through the stencil material sufficiently enough to easily position or center it where you want it.)

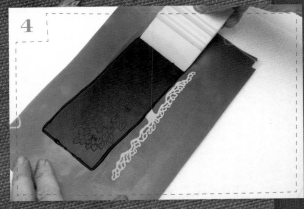

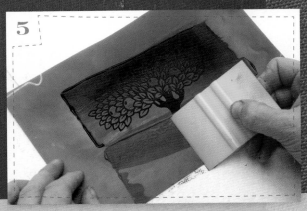

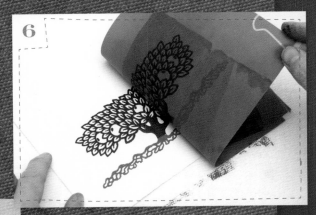

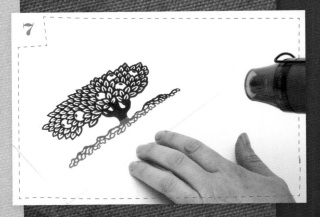

3 INK UP SQUEEGEE
Using a palette knife, apply some ink to the squeegee.

4 APPLY INK TO SCREEN
Run the inked squeegee over the image on the screen.

5 ADD ANOTHER COLOR
Add a second color in the same way.

6 REMOVE STENCIL SCREEN
Gently peel up the stencil to reveal your print.

7 SET INK WITH HEAT
Wash your screen so you can reuse it on another print.
Set the ink with a heat gun. Stich or embellish to add
final details, as desired.

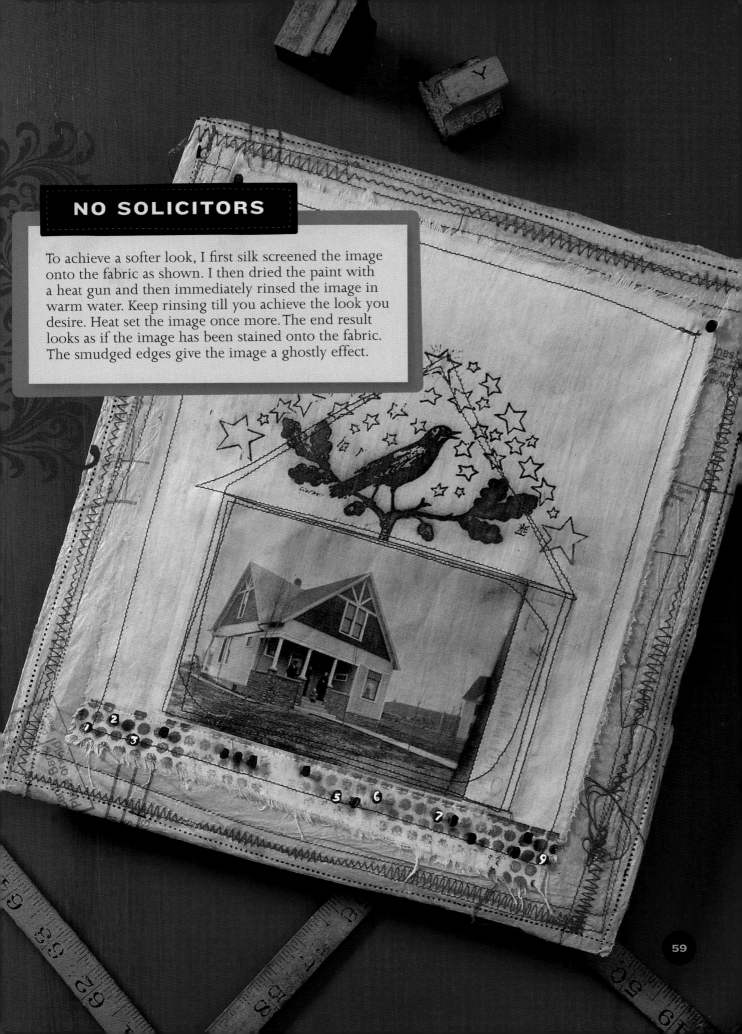

NO SOLICITORS

To achieve a softer look, I first silk screened the image onto the fabric as shown. I then dried the paint with a heat gun and then immediately rinsed the image in warm water. Keep rinsing till you achieve the look you desire. Heat set the image once more. The end result looks as if the image has been stained onto the fabric. The smudged edges give the image a ghostly effect.

wrapped

Baling wire is used to bale hay and mend fences on ranches (to keep the cows in and the coyotes out) and is a staple in every farmer's tool box. I am not a farmer or a rancher; I am a city girl who has her own uses for this pliable wonder. It is my material of choice for creating dimensional displays. It is inexpensive, and a spool seems to go on forever. Who would have thought that six dollars could buy endless feet of fun and amusement? In the following projects it is used as the base, a connector, a hanger and a holder. Baling wire is essentially annealed wire; it comes in many different gauges, each having their own unique use. The following projects feature basic wire-bending techniques—expand on these techniques to make your own unique pieces.

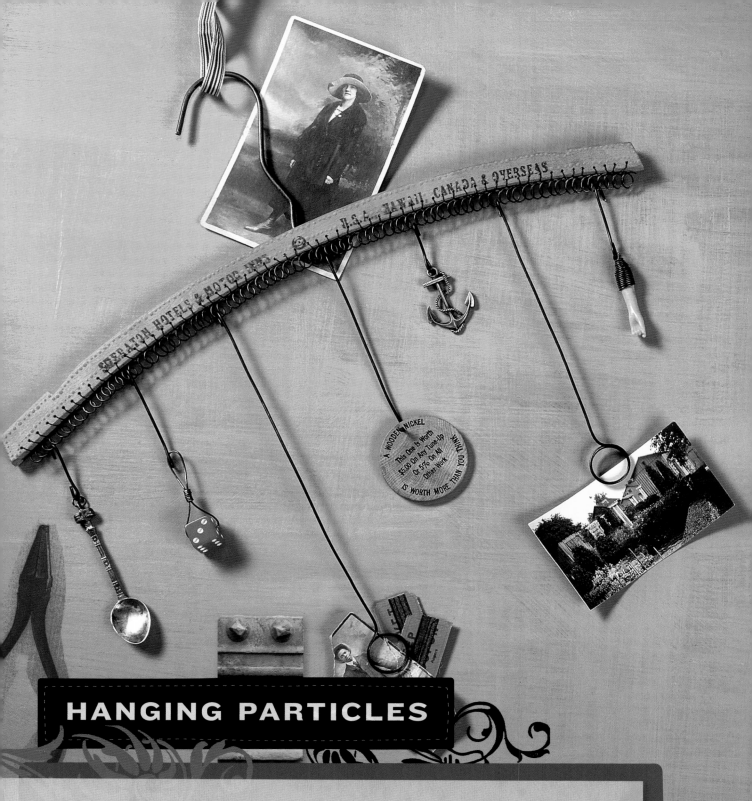

HANGING PARTICLES

With their own unique brand names and fonts, wooden hangers of the past have an intrinsic beauty of their own. Add a few baubles and decorative, handmade wire "lace," and turn an everyday innocuous object into a functional message or display board. Each hanging element contributes something unique and can be interchanged to fit your mood.

MATERIAL POSSESSIONS

* *

- 28-gauge annealed wire
- 19-gauge wire
- baling wire
- vintage dress hanger
- acrylic craft paint: teal
- retractable pencil

- ¼" (6mm) dowel
- ¾" (19mm) dowel
- drill and ¹/₁₆" (2mm) bit
- pliers pack (see page 10)
- hammer and metal block
- vise

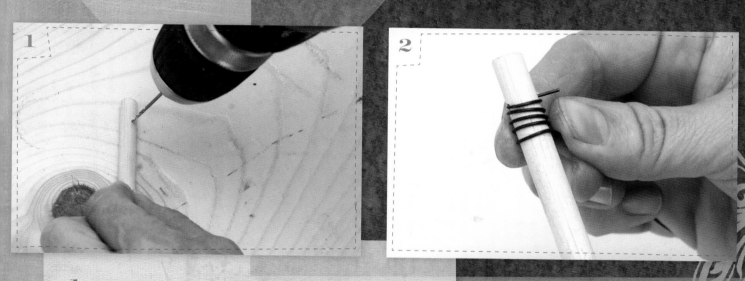

1 DRILL HOLE IN DOWEL
Use a drill to make a hole in one end of the ¼" (6mm) dowel.

2 BEGIN COILING WIRE
Working directly off of the 19-gauge spool of wire, insert the end into the hole and begin wrapping the wire around the dowel.

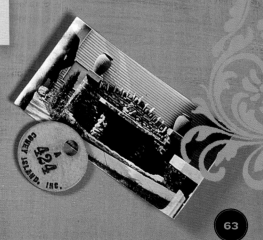

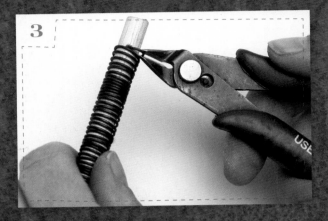

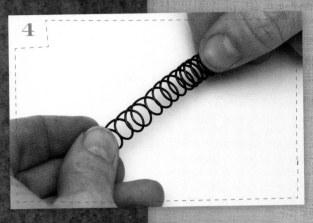

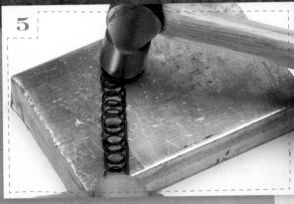

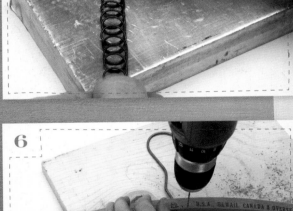

3 SNIP WIRE NEAR HOLE
Keep the wrapping snug and continue coiling it around until you have about a 12" (30cm) coil. Snip the wire where it went into the hole.

4 FLATTEN COIL
Remove the coil from the dowel. Use your hands to flatten and slightly spread the coil.

5 HAMMER COIL
Stretch the coil to slightly longer than the length of the hanger, and then hammer it on a metal block.

6 DRILL HOLES ALONG HANGER
Starting at the center and measuring out, mark for holes along the bottom edge of the hanger, every ¼" (6mm). Drill a hole at each mark.

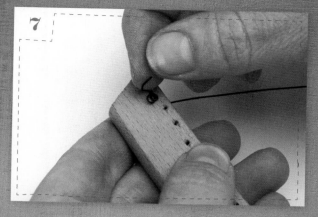

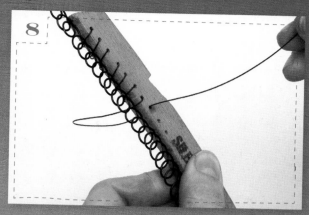

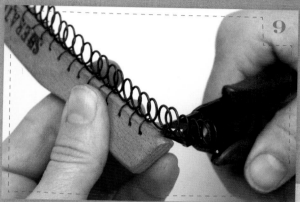

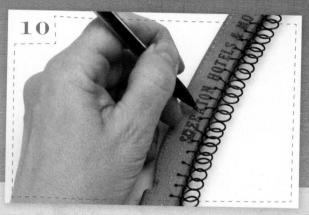

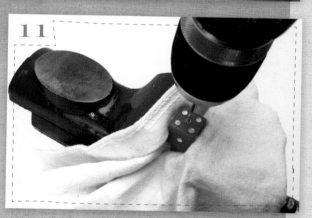

7 BEGIN SEWING WITH WIRE

Cut a length of 28-gauge wire to sew with, and create a small, tight coil at one end to make a "knot." Thread the wire through the hole on one end of the hanger and begin sewing the coil to the hanger.

8 KEEP COIL CENTERED

Leave a little overhang of the coil to start, if it's a bit long for the hanger, and you can trim it off when you're done. Pull the wire taut as you go, and keep the coil centered at the bottom of the hanger.

9 TRIM EXCESS COIL

When you reach the end of the hanger, pull the wire tightly through a couple of wire wraps just before the end, and snip the wire to leave about 1" (3cm). Then, coil the end as you did when you began, creating a sort of knot. Trim off the excess coil piece to be just a little bit shorter than the hanger.

10 ADD DECRATIVE PAINT DOTS

Use a retractable pencil to add teal paint dots along the top of the hanger, along the sides and just above the drilled holes.

11 DRILL HOLES IN OBJECTS

Choose five objects to hang from the hanger, and set each one in a vise to drill. You may want to protect the object by putting it in a towel before clamping the vise down.

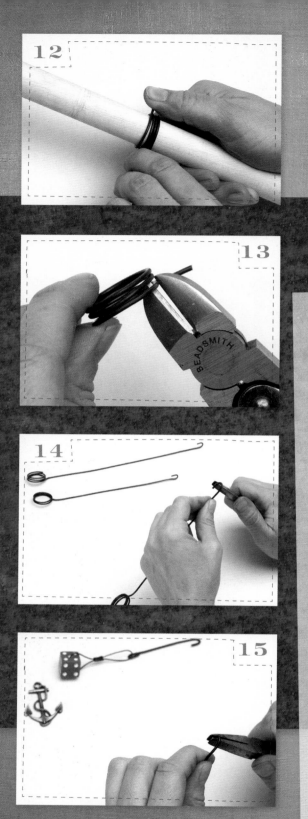

12 CREATE HANGERS AND PHOTO HOLDERS
Use 19-gauge wire to hang the objects. You may need to experiment with the wrapping to find the best solution for each item. I used a trapeze-like system for the dice and a coil wrap for the doll arm. To make a photo holder, cut a 24" (61cm) length of baling wire and wrap one end around the ¾" (19mm) dowel about three and a half times. Bend the remaining wire straight.

13 TRIM LOOP END
Take the wire off the dowel, and snip the short end of the wire to leave at least two rings.

14 CREATE A HOOK
Trim the long, straight end of the wire to the length you want it to hang, then create a small hook on the end. Create as many additional photo holders as you desire.

15 CREATE HANGERS FOR OBJECTS
To create hangers for the objects, create a hook at both ends of a length of wire, using round- or flat-nose pliers depending on how sharp you want the angle of the hook to be.

16 HAMMER WIRE TO SECURE OTHER OBJECTS
Another way to hang something is to drill a hole in it, just large enough to accommodate the wire, insert the wire through the hole, and then hammer the end of it flat to spread it, making it too wide to come back through the hole. (Fold the wire on each side of the object to hang.) Create a hook on the opposite end.

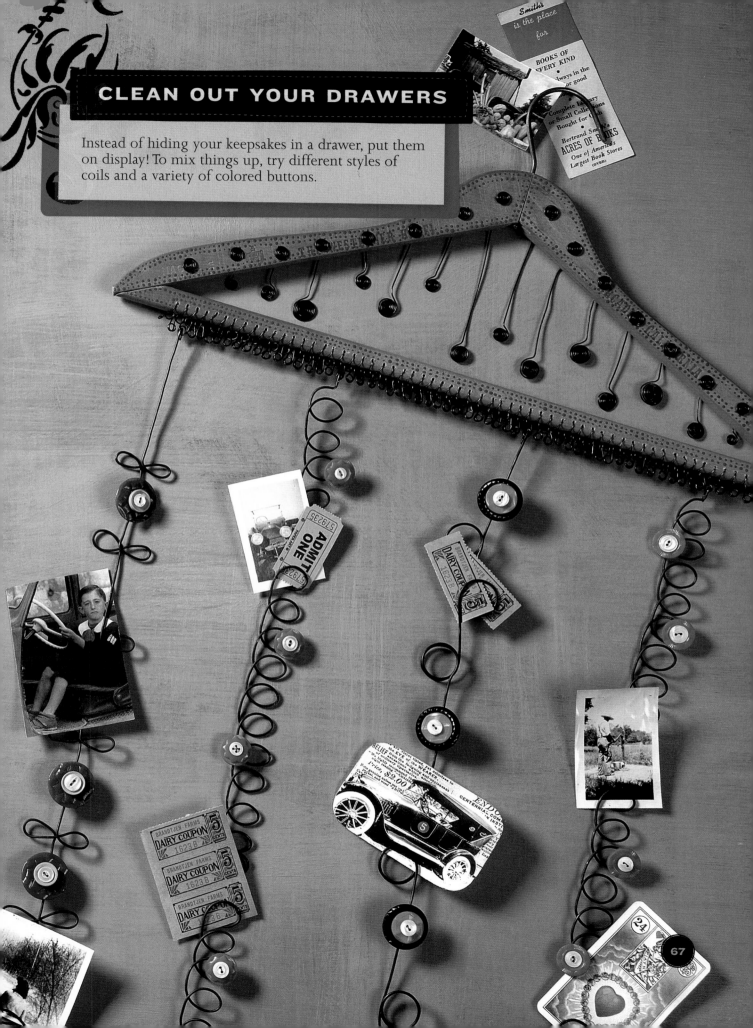

CLEAN OUT YOUR DRAWERS

Instead of hiding your keepsakes in a drawer, put them
on display! To mix things up, try different styles of
coils and a variety of colored buttons.

REACH OUT AND HOLD ME

hether you are showcasing one image or many, a dimensional wire stand is an interesting solution to feature selected pieces. This is a unique and space-saving way to show a grouping without putting seven nails in the wall. You can leave it out year-round and replace the art pieces seasonally or on a whim without busting out a ladder and a tool kit. As an alternative to game pieces, try using print letter blocks as feet.

MATERIAL POSSESSIONS

- baling wire
- 28-gauge annealed wire
- ¾" (19mm) dowel
- standard dice, four
- ruler
- pliers pack (see page 10)

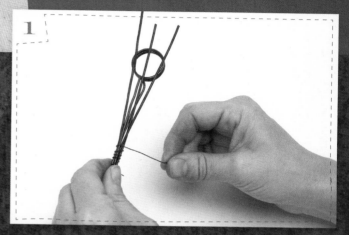

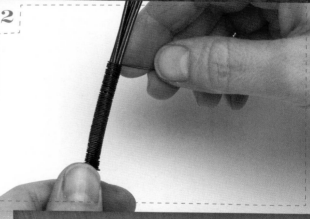

1 BUNDLE PHOTO HOLDER AND WIRES

Cut a 12" (30cm) length of baling wire and wrap it around the ¾" (19mm) dowel about three and a half times. Bend the wire straight at the end. Take it off the dowel, and snip the coil to leave at least two rings. Cut two more lengths of wire to about 18" (46cm) each. Hold the three pieces of wire together and tightly wrap some 28-gauge wire around them to hold as a bundle.

2 COIL WIRE AROUND BUNDLE

Make the pieces all flush at the bottom. Then, working directly off of the spool, begin wrapping 28-gauge wire around the bundle, working down from the top. Wrap until you have about a 2" (5cm) section bound. Trim the excess wire to leave about 3" (8cm) remaining.

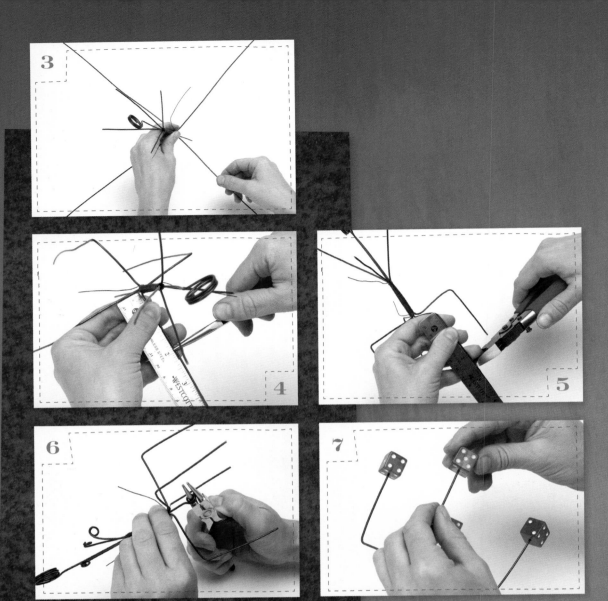

3 STRAIGHTEN FOUR LEGS

You can now remove the first piece of wire you put on the bundle to hold it together. Bend the four longer pieces of straight wire at the bottom up 90 degrees.

4 BEND EACH LEG DOWN

Measure out 2" (5cm) from the center on each piece and bend the wire straight down.

5 TRIM EXCESS FROM LEG WIRES

Measure from the bend in the wire down about 2½" (6cm) on each leg, and trim the excess to make them all even.

6 CURL WIRE ENDS

Use round-nose pliers to curl the ends of the four wires around the photo holder. Curl the portion of the photo holder wire below the bundle as well.

7 ATTACH FEET TO LEG WIRES

Arrange the wires how you want them. Choose four matching objects (here, I used the dice) for the feet and drill a ¹⁄₁₆" (2mm) hole in each. Insert one object onto the ends of each leg to finish. You may need to flex and fiddle with the legs to get the piece to stand correctly.

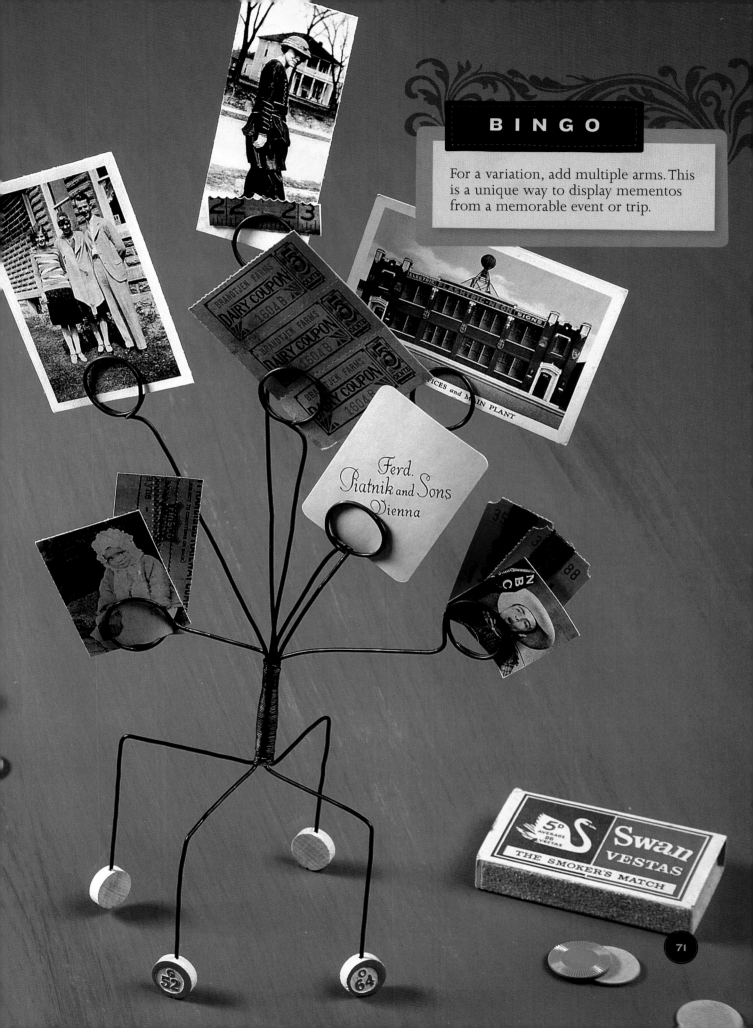

BINGO

For a variation, add multiple arms. This is a unique way to display mementos from a memorable event or trip.

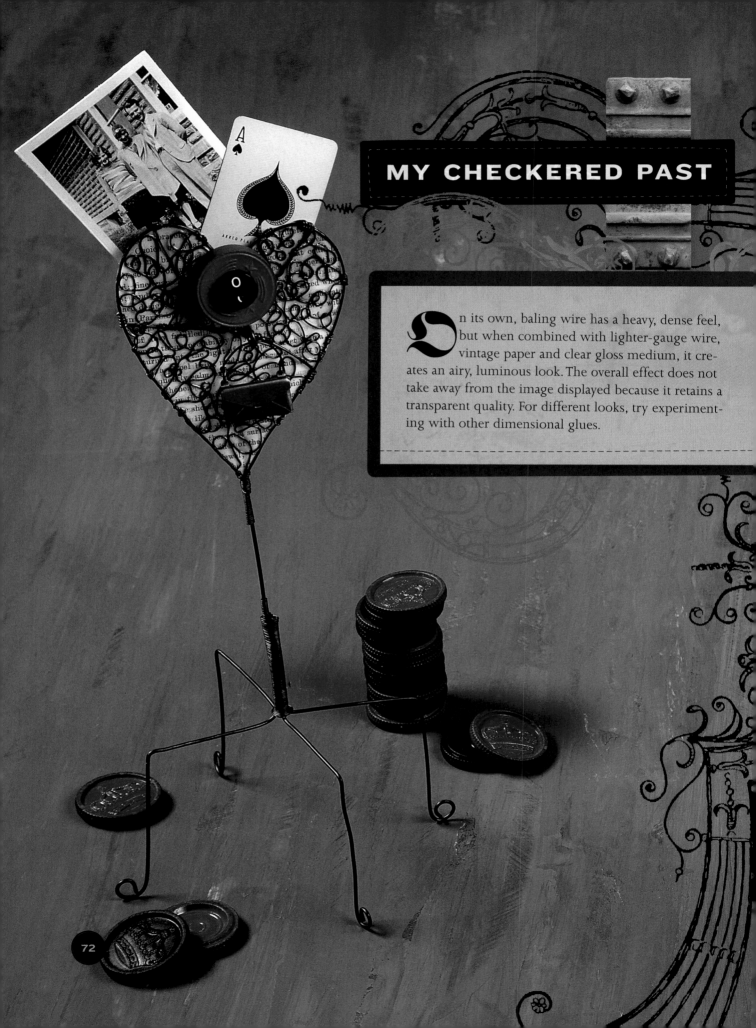

MY CHECKERED PAST

On its own, baling wire has a heavy, dense feel, but when combined with lighter-gauge wire, vintage paper and clear gloss medium, it creates an airy, luminous look. The overall effect does not take away from the image displayed because it retains a transparent quality. For different looks, try experimenting with other dimensional glues.

MATERIAL POSSESSIONS

* baling wire
* 28-gauge annealed wire
* old book page of text
* silicone craft sheet or parchment paper
* Glossy Accents (Ranger)
* typewriter key
* checker
* small charm
* ³/4" (19mm) dowel
* drill and ¹/16" (2mm) bit
* pliers pack (see page 10)
* hammer and metal block

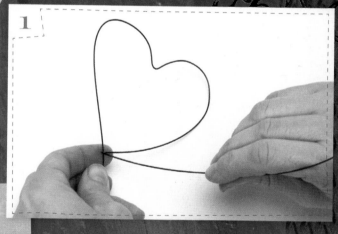

1 CREATE A HEART SHAPE
Form a 24" (61cm) length of baling wire into the shape of a heart (make your own shape, or use the template on page 123) and wrap the shorter end around the long end at the base of the heart about three times. Trim the wrapped end and leave the other end at about 6" (15cm).

2 SECURE CROSS WIRE
Wrap a piece of wire across the heart and trim the ends.

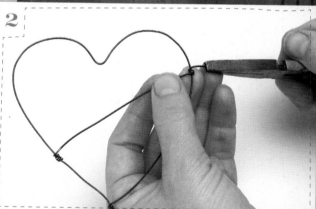

PLASTIC INTER

CHECK

WOLFE PRODUCTS, CO
SHEBOYGAN, WIS.

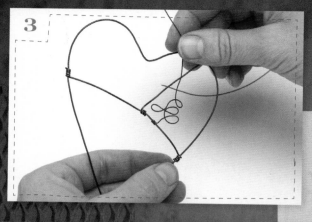

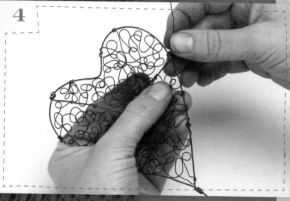

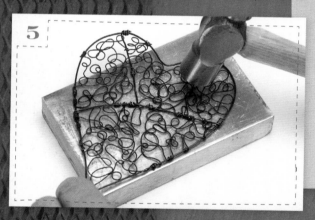

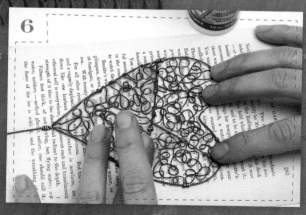

3 BEGIN FORMING LOOPS

Attach a piece of wire to the cross piece and wrap it to the side of the heart as well. Reshape the heart if necessary. Cut a piece of 28-gauge wire to a length you are comfortable with. (I started with about 36" [91cm]). Attach one end of the wire to one of the cross pieces of wire. Begin forming freeform, flattened loops with the 28-gauge wire.

4 FILL HEART WITH CURLICUES

After you have made between eight and ten curlicues, wrap the wire around the heart wire (or a cross wire) and trim. Then, start a new piece and repeat. You might find you don't need to trim the wire; you can just wrap it around the larger wire and keep going. Continue until the heart is full.

5 HAMMER PIECE

Hammer the entire piece when you're done to make everything nice and flat.

6 SPREAD MEDIUM OVER HEART AND PAPER

Working on a craft sheet, set the heart over the book page and begin squeezing on the Glossy Accents medium. Spread and work it into the wire crevices with your finger. If it oozes outside of the heart, clean it up with your finger. Set the piece aside to dry.

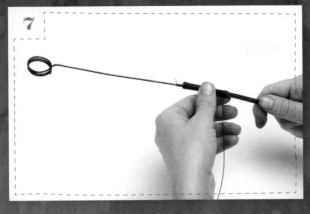

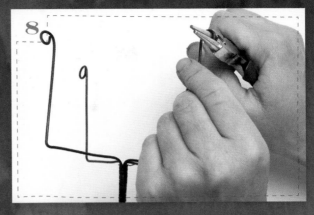

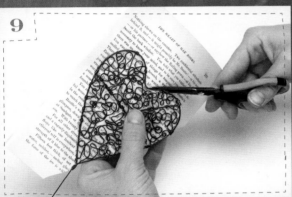

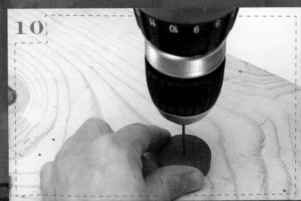

7 SECURE PHOTO HOLDER TO LEG WIRES

Cut a 20" (51cm) length of baling wire and on one end, create a two-ringed photo holder (see page 69). Cut four 12" (30cm) lengths of baling wire and, using 28-gauge wire, bind them together with the photo holder. The photo holder should be about 2" (5cm) shorter than the 12" (30cm) pieces, which should all be flush at the bottom. (See page 69 for more info.)

8 BEND WIRES TO MAKE LEGS AND FEET

Bend each leg out 90 degrees and at 2½" (6cm) make a bend. Then, trim each leg to be even, about 2½" (6cm) from the bend. Curl the ends of each leg to create feet.

9 TRIM PAPER AROUND HEART

When the heart and paper piece is dry, carefully trim the excess paper from the outside of the heart using scissors.

10 DRILL HOLE IN CHECKER AND TYPEWRITER KEY

Next, drill a hole in the typewriter key and also in the checker.

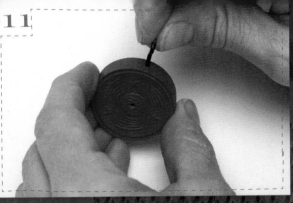

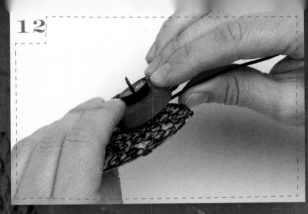

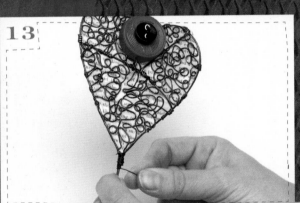

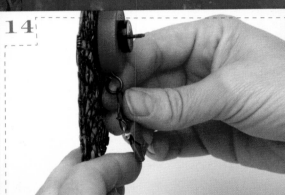

11 SECURE HOOK IN CHECKER

Drill a hole at the side of the checker as well. Cut a short piece of wire and, using pliers, create a hook on one end. Insert the other end into the checker. Hammer it in a bit if you need to.

12 SECURE PIECES TO HEART

Cut a 6" (15cm) length of wire and hammer the tip flat at one end. Insert the other end through the typewriter key, the checker and then the heart. Bend the wire down to secure the pieces, and trim the excess so that it doesn't show.

13 SECURE HEART TO STAND

Finally, use 28-gauge wire to wrap the heart wire to the stand until it feels secure. Trim the excess wire.

14 HANG CHARM TO FINISH

Fiddle with the photo holder and the legs to position as desired. Hang a little charm from the hook that you put on the checker.

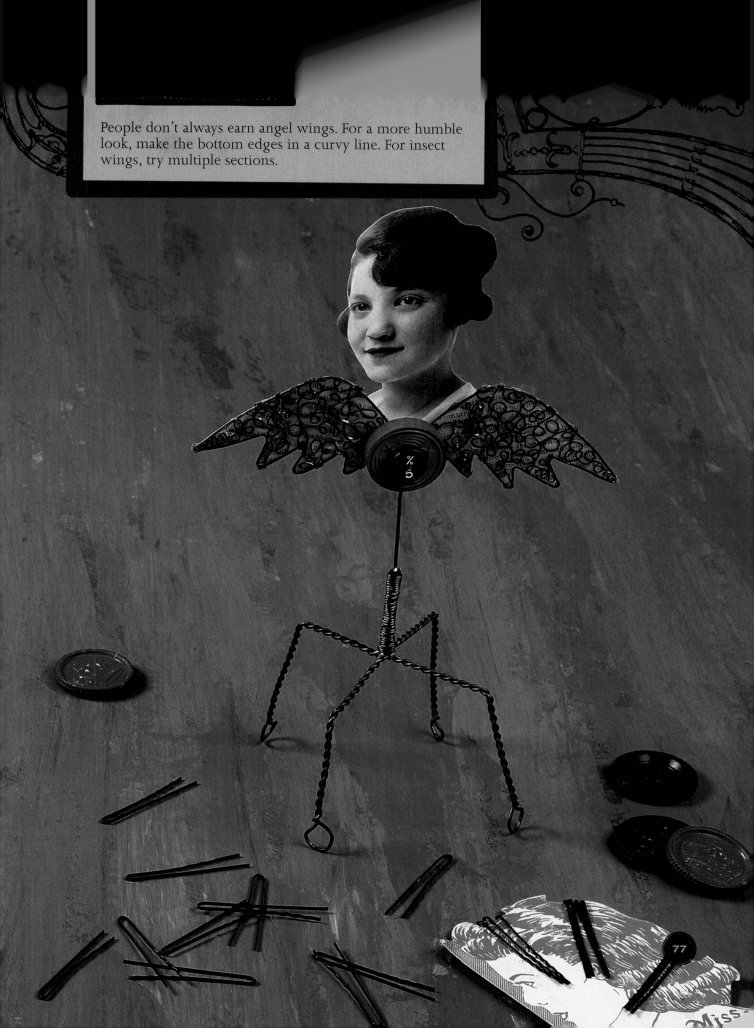

People don't always earn angel wings. For a more humble look, make the bottom edges in a curvy line. For insect wings, try multiple sections.

worn

By no means do I think of myself as a fine jewelry maker or a trained metalsmith, and I am living proof that you don't need to be either to master cold connections. Without having to solder or use a torch, basic cold connections open up the doors for even a beginner to master the techniques that let you create one-of-a-kind, wearable works of art. The cold connections we will be exploring include micro-screws, eyelets, rivets and staples/prongs. Cold connections enable you to give new life to recycled objects. If, like mine, your workroom is already cramped, and by some people's standards, might be considered a fire hazard, making cold connections can be done without the worry of your scrapbook papers going up in flames. In this section, you'll also learn the simple use of chemical solutions to age pieces of metal.

Who doesn't love a beautiful button? Take a plain white shirt add hand-carved shell buttons, and it takes on an entirely different look. That plain white shirt turns into wearable art. Take those buttons off the shirt, pair them with other unique buttons, and you have a beautiful piece of wearable-art jewelry. The thing I like most about this project is the endless variety of styles and colors of buttons available. This cold connection allows you to use the most exquisite of antique buttons without altering their integrity or value.

MATERIAL POSSESSIONS

* 20-gauge annealed wire
* 28-gauge annealed wire
* scrap paper
* pencil
* plastic vintage buttons

* ³⁄₁₆" (5mm) dowel
* pliers pack (see page 10)
* hammer and metal block

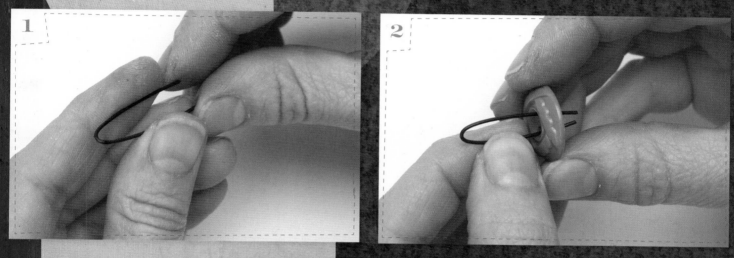

1 BEND SHORT PIECE OF WIRE
Cut a 2½" (6cm) length of 20-gauge wire
and bend it in half, forming a U shape.

2 INSERT INTO BUTTON
Insert the wire through the holes of a button.

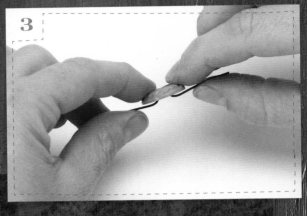

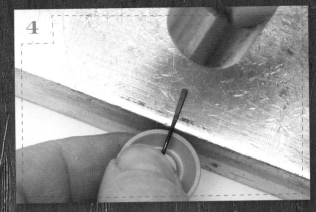

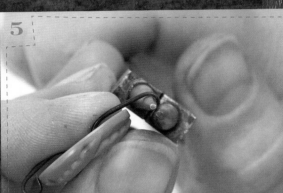

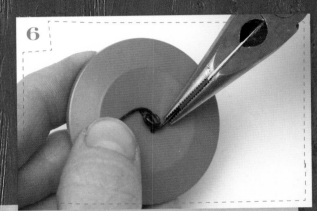

3 EXTEND WIRE ENDS
Push the wire all the way to the surface of the button, then spread out the wire in back.

4 HAMMER WIRE ENDS
Trim the wire ends down to about ⅜" (10mm) beyond the edge of the button and hammer the ends flat.

5 CURL WIRE ENDS
Using round-nose pliers, curl the ends into the shape of a circle to act as a connector or jump ring.

6 CREATE A CENTER PIECE
Repeat this process for as many buttons as you wish, creating several button "links." For the center piece, stack three buttons together and, instead of creating jump rings with the ends of the wire, twist the two wire ends together.

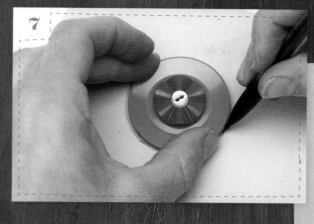

7 TRACE BUTTON ON PAPER
Now, trace the diameter of the outer button on a piece of paper.

8 BEND WIRE INTO PRONGS
Draw a cross across the circle to divide it into quarters. Use this as a guide to create a series of prongs as shown, using two pieces of wire.

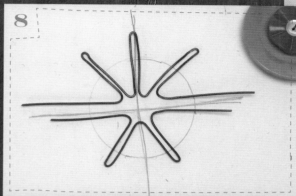

9 CONNECT PIECES AND HAMMER
Cut a length of 28-gauge wire and wrap the two halves together. Then hammer the wrapped section flat.

10 FOLD PRONGS OVER BUTTON
Hammer the ends of the prongs flat. Center the button over the pronged piece and fold over the prongs that will hold the button (positioned at noon, 5 o'clock and 7 o'clock). Leave the prongs at 10 o'clock and 2 o'clock flat.

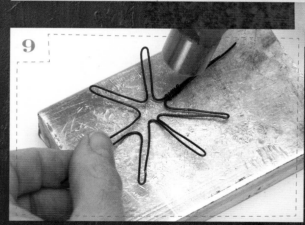

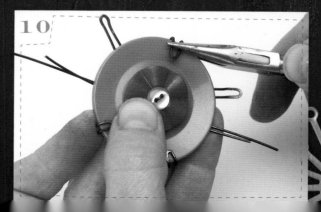

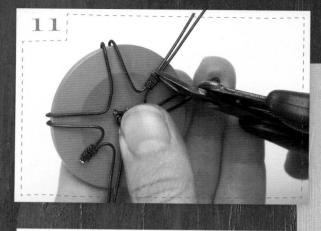

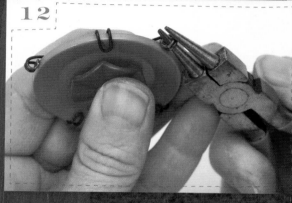

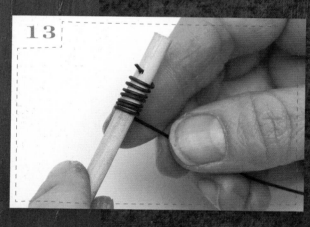

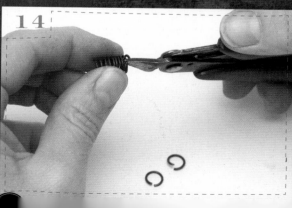

11 TRIM EXCESS WIRE
Trim off the long extra pieces of wire.

12 CURL TWO CONNECTORS
Curl the remaining two pieces into rings to act as connectors.

13 COIL WIRE FOR JUMP RINGS
To create jump rings, coil a length of 20-gauge wire around the dowel.

14 CUT APART RINGS
Remove the coil, and then use the wire cutters to cut apart the individual rings.

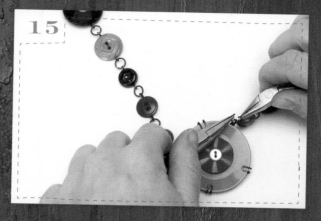

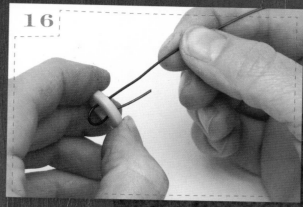

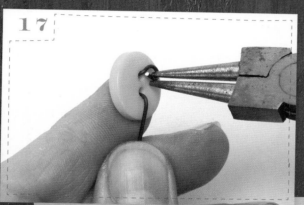

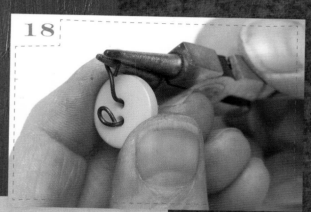

15 LINK BUTTONS TOGETHER

Lightly hammer each of the rings. Make enough to connect all of your button links. Then, use one jump ring to connect each button to another to form the complete necklace.

16 THREAD BUTTON FOR CLASP

To create a clasp, start with a 3" (8cm) length of 20-gauge wire and fold a U on the end. Insert the ends through the button.

17 CREATE A LOOP

Fold the wire out flat in the back, and trim one end down to leave about ¼" (6mm). Curl that into a little loop.

18 CREATE CONNECTION FOR NECKLACE

Trim the other end, leaving about ½" (13mm) of wire, and create another loop on that end. Attach the button to one end of the necklace using a jump ring and the larger loop.

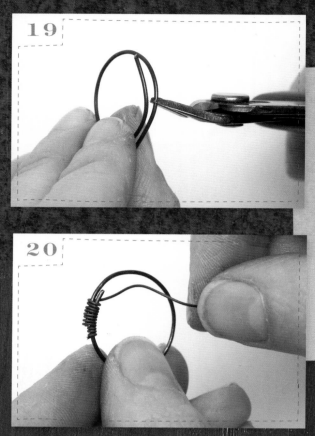

19 MAKE A LARGE CIRCLE

With a new piece of 20-gauge wire, create a circle slightly larger than the diameter of the clasp button. Overlap the ends a bit and trim.

20 SECURE ENDS WITH WIRE

Use a piece of 28-gauge wire to wrap the ends together to secure. Wrap just beyond the ends of the wire.

21 SECURE RING TO NECKLACE

Lightly hammer the wrapping. Attach the ring to the jump ring of a button link on the other end of the necklace.

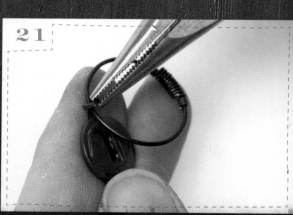

TRY IT
(you'll like it)

To create more interest, try stacking a tiny button on top of a larger button and repeating steps 1–5.

BUTTON UP

If you're short on vintage buttons, check out the shirt racks at thrift shops and harvest them right off of the shirts. The Internet is another place to find a plethora of styles and sizes.

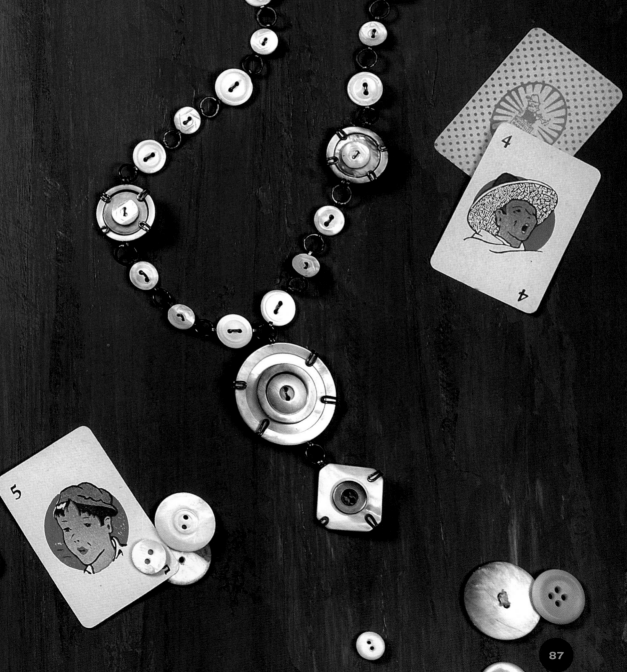

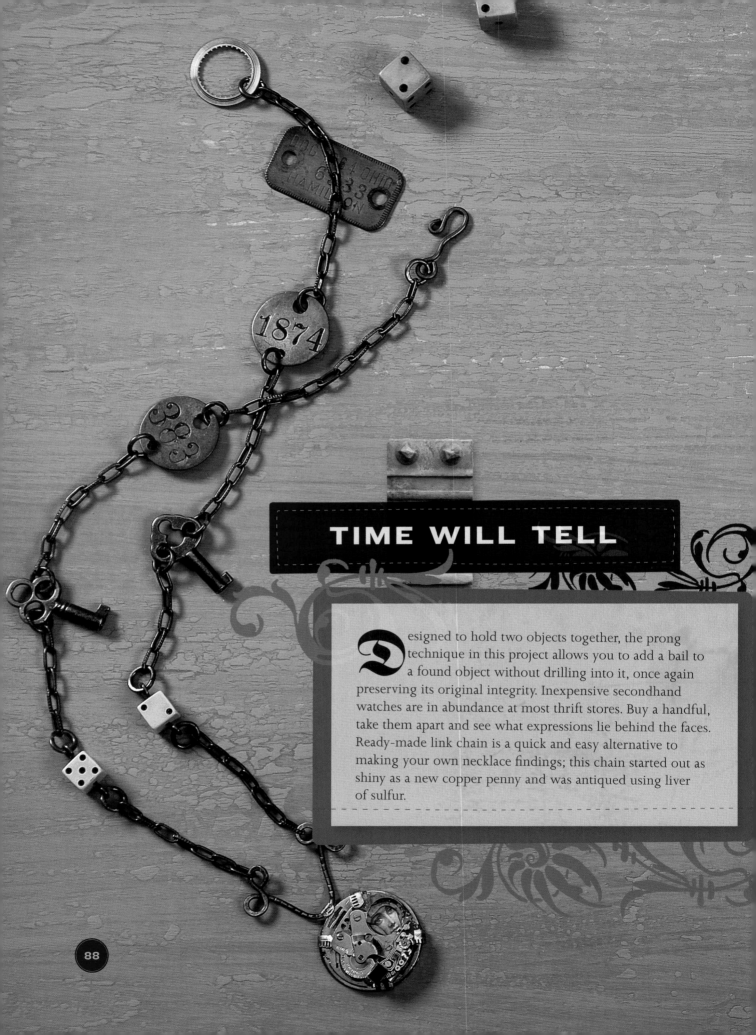

TIME WILL TELL

Designed to hold two objects together, the prong technique in this project allows you to add a bail to a found object without drilling into it, once again preserving its original integrity. Inexpensive secondhand watches are in abundance at most thrift stores. Buy a handful, take them apart and see what expressions lie behind the faces. Ready-made link chain is a quick and easy alternative to making your own necklace findings; this chain started out as shiny as a new copper penny and was antiqued using liver of sulfur.

MATERIAL POSSESSIONS

★★★★★★★★★★★★★★★★★★★★★★★★★★★★★★★★★

- 14-gauge copper wire
- 19-gauge copper wire
- 22- or 24-gauge sheet copper
- ready-made copper chain, about 18" (46cm)
- beeswax
- liver of sulfur
- ³⁄₁₆" (5mm) dowel
- dismantled watch piece that has a hole where the date portion was
- vintage metal tag
- two small dice
- two small keys
- double-sided tape

- metal shears (combi snips)
- scissors
- 400-grit wet/dry sandpaper
- pliers pack (see page 10)
- scribe tool
- drill and ¹⁄₁₆" (5mm) bit
- hammer and metal block
- rubber or rawhide mallet
- decorative punch or screwdriver
- jeweler's saw and vise
- bastard file

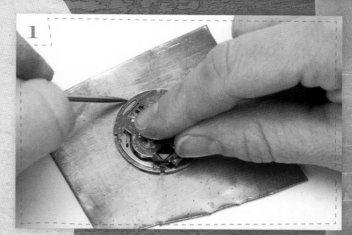

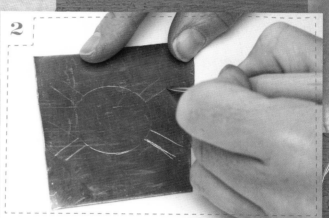

1 TRACE WATCH PIECE

Flatten a piece of sheet copper with a rubber mallet, and then trace the watch piece onto the sheet, using a scribe.

2 SCRIBE PRONGS ONTO SHEET

Use the scribe to then mark for five prongs at approximately 11 o'clock, noon, 1 o'clock, 5 o'clock and 7 o'clock.

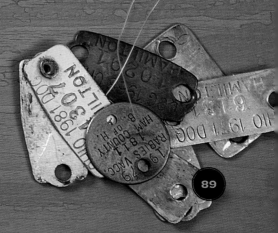

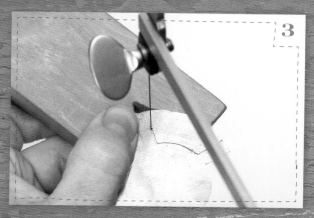
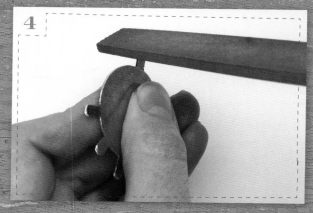
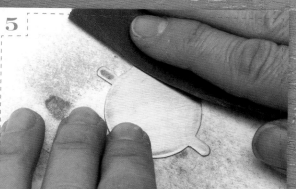
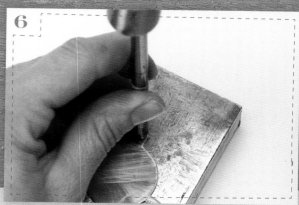

3 CUT OUT SHAPE WITH SAW

Remove the excess metal outside of the prong areas with the shears. Place the metal piece on a jeweler's vise. Apply some wax to the blade, and then begin sawing to remove the metal between the prongs. Start on the outside of the circle, saw toward the center and, when you need to turn, keep sawing lightly up and down as you gently turn the metal.

4 TRIM AND FILE PRONGS

Decide how long the prongs really need to be and trim them with shears. Here, my watch is relatively thin, so ¼" (6mm) will be long enough. If you like, you can also round the corners of the prongs slightly, so they aren't sharp. In one direction only, file all of the edges with a bastard file.

5 SAND ENTIRE PIECE

When the edges are nice and smooth, go over the entire surface with fine sandpaper.

6 PUNCH DETAILS ONTO PRONGS

Use a hammer and a decorative punch (or screwdriver) to add detail lines to the side of the prongs that will be visible when they are folded over.

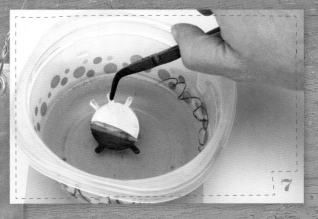

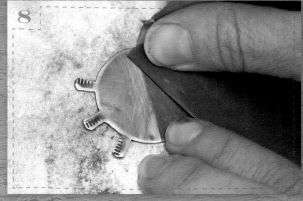

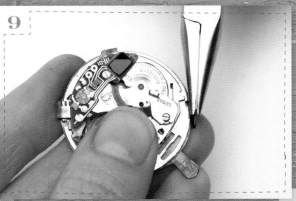

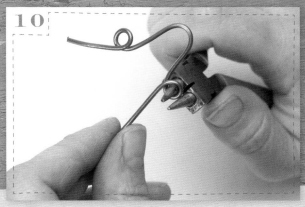

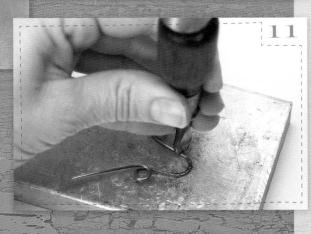

7 BLACKEN COPPER

Mix up liver of sulfur in a container and set the copper piece in it. How long you leave it in is up to you. I usually just dip it in and take it out.

8 POLISH WITH SANDPAPER

Rinse off the piece and let it dry. Go over the entire piece again with the fine sandpaper to remove some of the blackness.

9 SECURE COPPER TO WATCH

Cut out an image to show through the hole on the watch piece with scissors. Use a small amount of double-sided tape to hold the image in place under the watch. Set the watch on the copper piece and fold the prongs over to secure the copper to the watch.

10 SHAPE WIRE FOR BAIL

For the prong at the top of the watch, curl it to form a bail for the chain. Cut about a 5" (13cm) length of 14-gauge copper wire and create a section for the bail to hang on by making a U shape in the middle. Then form a loop on either side.

11 ADD TEXTURE TO WIRE

Use a screwdriver and hammer to create a texture on the wire.

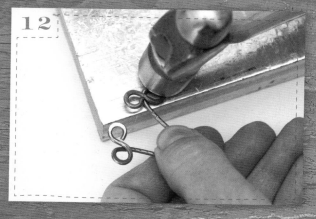

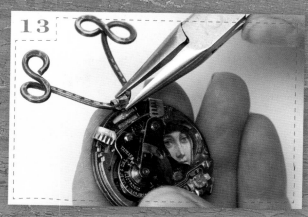

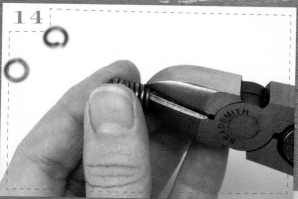

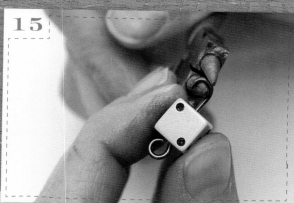

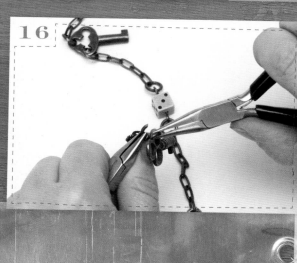

12 HAMMER FINAL LOOPS

Hammer sections of the finding flat with the hammer. Use round-nose pliers to create a final loop on each end of the wire, and hammer those flat as well.

13 ATTACH WATCH TO WIRE

Dunk the finding in the liver of sulfur and rinse, dry and sand it a bit. Attach the watch to the finding.

14 CREATE BLACKENED JUMP RINGS

Dip the copper chain and a 10" (25cm) length of 14-gauge copper wire into liver of sulfur; rinse and dry. Coil the wire around the ³/₁₆" (5mm) dowel and cut into fourteen jump rings.

15 CREATE CONNECTORS FOR DIE

Hammer the jump rings slightly, on a metal block. Cut a small length of 19-gauge wire that is about 1" (3cm) longer than your die. After drilling a hole through the die, thread the wire through the hole and, using round-nose pliers, create a loop on each end, bending the wire back slightly to center the loop.

16 CONNECT PIECES TOGETHER

Randomly connect the die and the keys to sections of the chain using the jump rings and pliers.

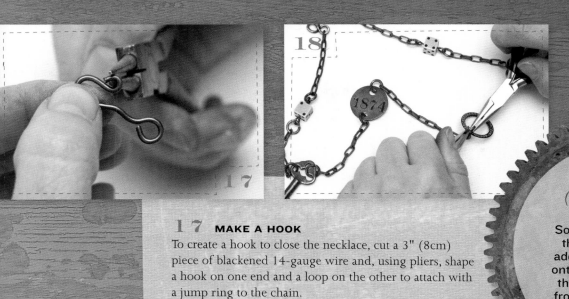

17 MAKE A HOOK

To create a hook to close the necklace, cut a 3" (8cm) piece of blackened 14-gauge wire and, using pliers, shape a hook on one end and a loop on the other to attach with a jump ring to the chain.

18 ATTACH WATCH FINDING

For the other half of the clasp, attach a watch date dial to the other side of the chain with a jump ring.

TRY IT
(you'll like it)

Sometimes it's the little things: I like to brush additional liver of sulfur onto my jump rings after they've been cut apart from the coil, to age the exposed inside of the copper wire.

SEE THROUGH

Adding custom findings to a pre-made chain is one of many ways to make it your own.

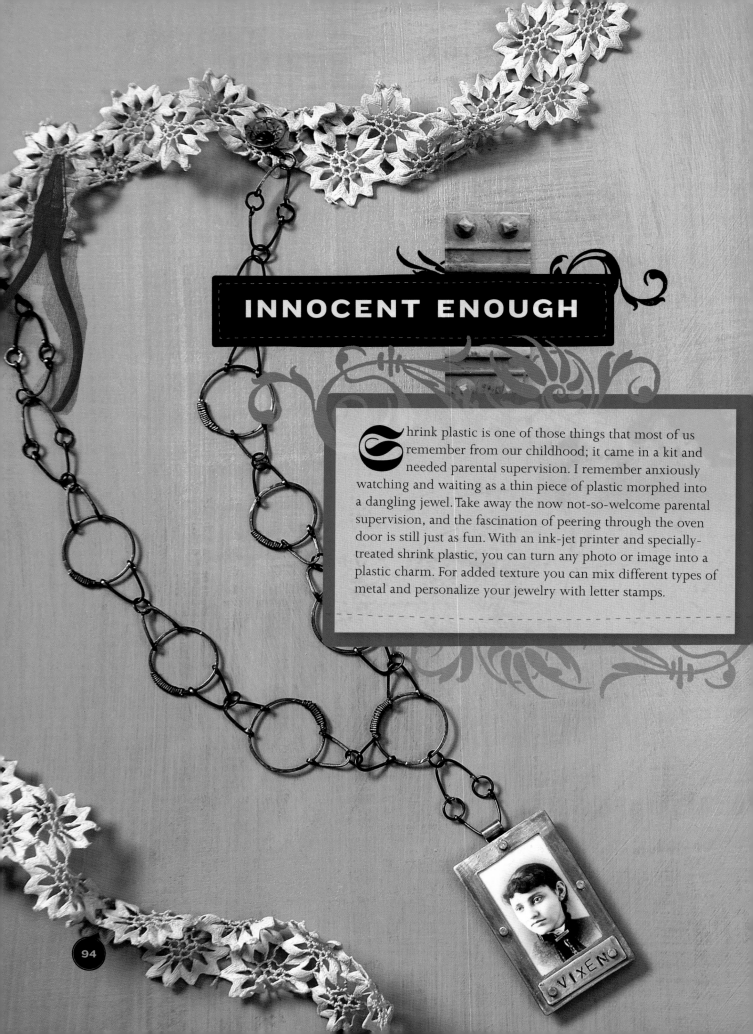

INNOCENT ENOUGH

hrink plastic is one of those things that most of us remember from our childhood; it came in a kit and needed parental supervision. I remember anxiously watching and waiting as a thin piece of plastic morphed into a dangling jewel. Take away the now not-so-welcome parental supervision, and the fascination of peering through the oven door is still just as fun. With an ink-jet printer and specially-treated shrink plastic, you can turn any photo or image into a plastic charm. For added texture you can mix different types of metal and personalize your jewelry with letter stamps.

MATERIAL POSSESSIONS

- 20-gauge annealed wire
- 28-gauge annealed wire
- 22- or 24-gauge sheet copper
- 22- or 24-gauge sheet nickel
- printer-compatible shrink plastic (Shrinky Dinks)
- blackening solution (JAX Pewter Black)
- liver of sulfur
- pencil
- black permanent marker
- old photo, computer/scanner and inkjet printer
- scissors
- craft knife
- scribe tool

- metal shears
- 400-grit wet/dry sandpaper
- toaster oven
- ¾" (19mm) dowel
- pliers pack (see page 10)
- rubber mallet
- hammer and metal block
- metal letter stamps
- micro bolt washer and nut
- semi-gloss spray sealer (Deft)
- drill and ⅟₁₆" (2mm) bit
- jeweler's saw
- jeweler's vise and bench peg
- awl or needle tool

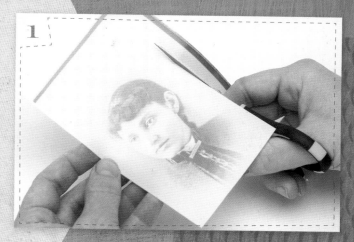

1 CUT IMAGE OUT OF PLASTIC

Scan a photo into your computer and print it out on a piece of shrink plastic. Cut the image out with scissors. (Note: The colors of the image will be concentrated after it has shrunk, so a pale image is preferable to start with.)

2 SHRINK AND SEAL

Shrink the plastic piece in the oven, according to the package directions. Spray the piece, when it has cooled, with a light coat of semi-gloss sealer.

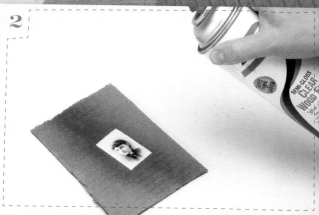

3 CREATE FRAME TEMPLATE

Create a template for the plastic piece by first tracing it onto a piece of paper, and then cutting out an even rectangle that is just a bit larger than the traced line. Using your portrait as a guide, decide what size window you want cut out of the template. Cut out the window using a craft knife.

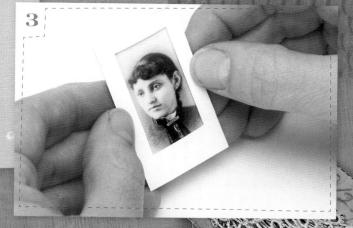

TRY IT
(you'll like it)

Use the lightest setting on the printer, as the colors will be much more concentrated after the piece has shrunk.

95

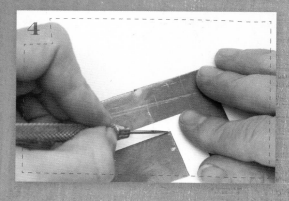

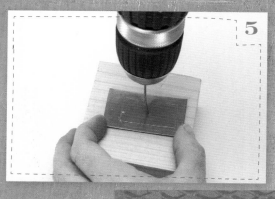

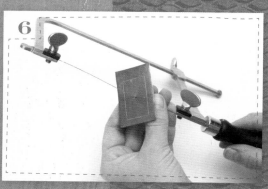

4 TRACE TEMPLATE ONTO COPPER
Use a scribe to trace the template on the sheet copper.

5 DRILL A HOLE IN CENTER OF WINDOW
Trim the outside of the shape with shears. To cut out the window portion, begin by drilling a ¹⁄₁₆" (2mm) hole somewhere in the center.

6 ENGAGE SAW BLADE
Release the blade from the saw on one end and stick it through the hole. Be sure that the scribed side is facing up so you can see it when you start sawing.

7 SAW OUT WINDOW SHAPE
Saw from the hole to the scribed line, and then turn and start sawing on the line, simultaneously moving the saw up and down as you rotate the metal piece. You'll need to do that at each corner. Continue sawing until the window has been cut out.

8 DISENGAGE SAW
Unlatch the saw blade again to get the copper piece off of the saw.

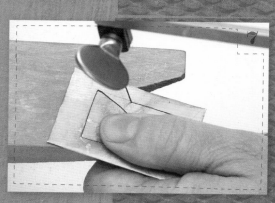

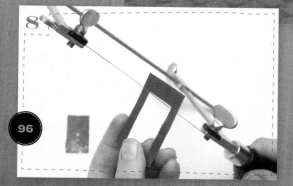

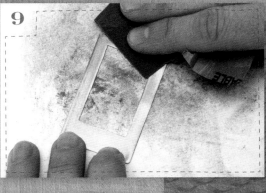

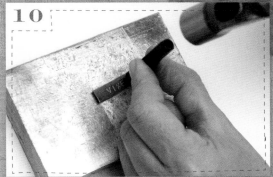

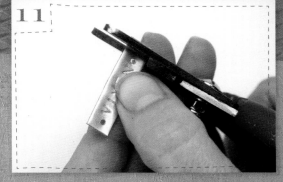

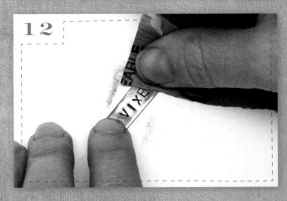

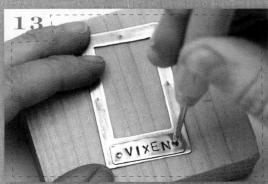

9 SAND COPPER FRAME

Hammer the frame with a rubber mallet to re-flatten it. Using fine sandpaper, sand the entire piece on both sides.

10 STAMP OUT LABEL

Cut a strip of sheet nickel to use as a label for your image. Cut it a bit longer than you need it to be so you can more easily center the letters. Use a hammer and the letter stamps to stamp out your chosen word. Rather than hitting the letter only once, I hold the stamp in place and hit it numerous times with the hammer, working in a circular pattern of strikes.

11 DRILL HOLES AND TRIM LABEL

Use a nail set to mark indentations where you will drill a hole. (This prevents the drill bit from walking across your surface.) Drill a hole at each mark. Then trim the excess portion of the strip down to just outside of the holes.

12 BLACKEN AND SAND LABEL

Dip the label in the blackening solution, and then rinse, dry and lightly sand.

13 MARK FOR HOLES

Dip the copper frame into the liver of sulfur, and then rinse, dry and resand. Use a scribe to mark and drill one hole at the top and two holes on the sides of the copper piece. Also, use the label to mark the holes where the label is going to go.

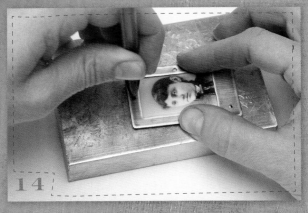

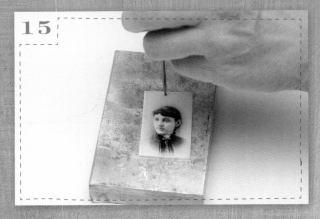

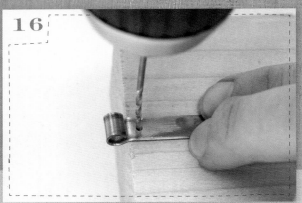

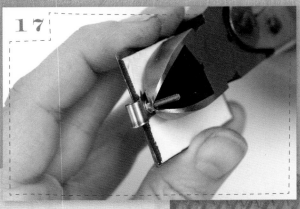

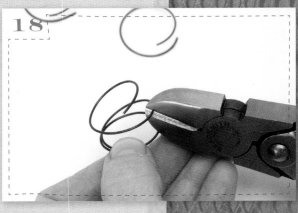

14 MARK SHRINK PLASTIC
Drill a hole at each mark on the copper. Use a pencil to mark for one of the holes on the piece of shrink plastic.

15 CREATE AN INDENTATION
Remove the copper and use an awl or needle tool to make an indentation in the center of the mark.

16 PREPARE A BAIL
Drill a hole in the shrink plastic at that mark. Now, you need to create a bail. Cut a thin piece of sheet copper about ¼" × 1½" (6mm × 4cm) and dip it in liver of sulfur. Rinse it and let dry, and then sand it. Use round-nose pliers to curl one end. Then mark and drill a hole at the other end.

17 SNIP EXCESS BOLT
Use a black permanent marker to color in the four edges of the shrink plastic. Assemble the pieces with the frame, the shrink plastic and the bail in the back, and insert a micro bolt from the front to the back. Add a washer and tighten a nut on the back. Use cutters to snip off the excess amount of bolt.

18 CUT OVERLAPPING JUMP RINGS
Use a file to remove the burrs from the bolt. With one bolt secured, repeat for the remaining holes, remembering to include the label at the bottom. Working off of the roll of 20-gauge wire, coil it around the ¾" (19mm) dowel to create at least nine coils, so you have enough overlap to create seven rings. Cut the rings apart, leaving about ½" (13mm) of overlap.

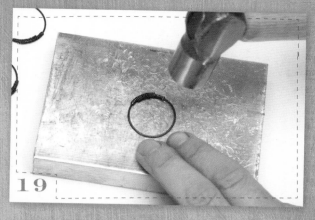

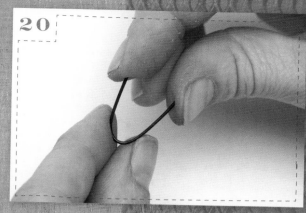

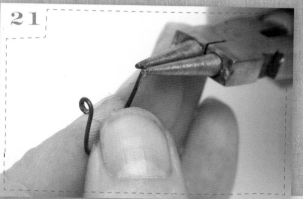

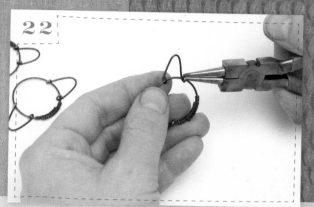

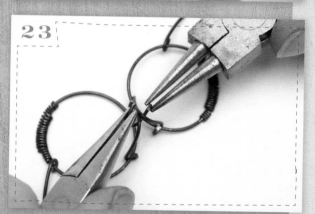

19 WRAP AND HAMMER RINGS
To create each ring, cut a 6" (15cm) length of 28-gauge wire and wrap it around the overlapped portion of a ring, going beyond the ends just a bit. Repeat for six more rings. Hammer each lightly with a hammer on a metal block.

20 BEND WIRE FOR CONNECTOR
For half-oval connectors, start with a piece of 20-gauge wire that is 1½" (4cm). Bend it in half slightly.

21 MAKE LOOPS ON ENDS
Hammer the ends just a bit, and then create a small loop with round-nose pliers on each end.

22 CONNECT TO RINGS
Repeat to make twenty-one more pieces. Connect the small loops of one half-oval piece to each side of a ring.

23 CONNECT PIECES FOR NECKLACE
With a ¼" (6mm) dowel and more 20-gauge wire, create twenty-three small jump rings (see page 84). Connect two pieces together with a jump ring and repeat until you have connected all of the circles.

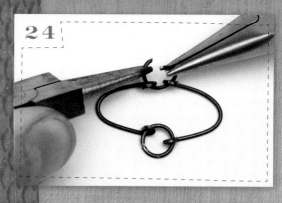

24 CREATE ONE OVAL LINK
Now, take two half-oval shapes and create a full oval by connecting them with two jump rings.

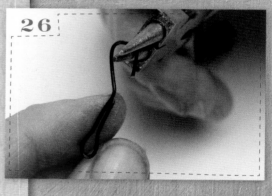

25 SLIDE PHOTO PIECE ONTO ONE OVAL
Repeat this connection to create four more ovals. For one of the ovals, slide the copper frame bail onto one U before closing.

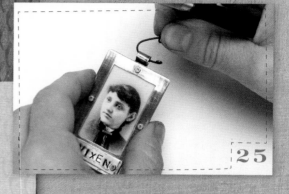

26 BEND WIRE INTO HOOK
With jump rings, connect two ovals to each side of the necklace. To create a hook, cut a length of 20-gauge wire to 1¾" (4cm). Bend the wire into a hook at one end. Fold the other end in half with a loop in the middle of it.

27 COMPLETE HOOK
Wrap the two overlapping pieces with 28-gauge wire and, using the round-nose pliers, bend the end of the hook up and back.

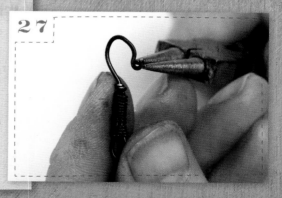

28 CREATE CIRCLE FOR CLASP
Cut a freehand circle from the sheet copper. Drill a hole in the center of the circle and stamp shapes or texture on it with a hammer. Dip the circle in liver of sulfur, and then rinse, dry and sand it. Cut a 1½" (4cm) length of 20-gauge wire and create a coil on one end. Stick the other end through the circle.

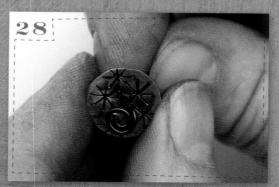

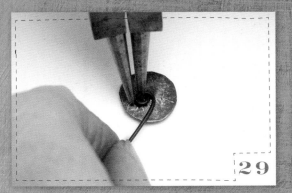

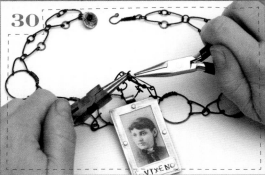

29 SECURE WIRE TO CIRCLE
Coil the wire on the other side to secure it.

30 ATTACH FRAME AND CLASP TO NECKLACE
Create a loop at the end of the wire and bend it back a bit, and then attach it to one end of the necklace. Attach the hook portion to the other end of the necklace with a jump ring. Using a jump ring, attach the frame piece to the center ring, and your necklace is complete.

CIRCUIT BOARD MARY

Discarded computer components have ready-made color, texture and design. Use a jeweler's saw to cut out shapes.

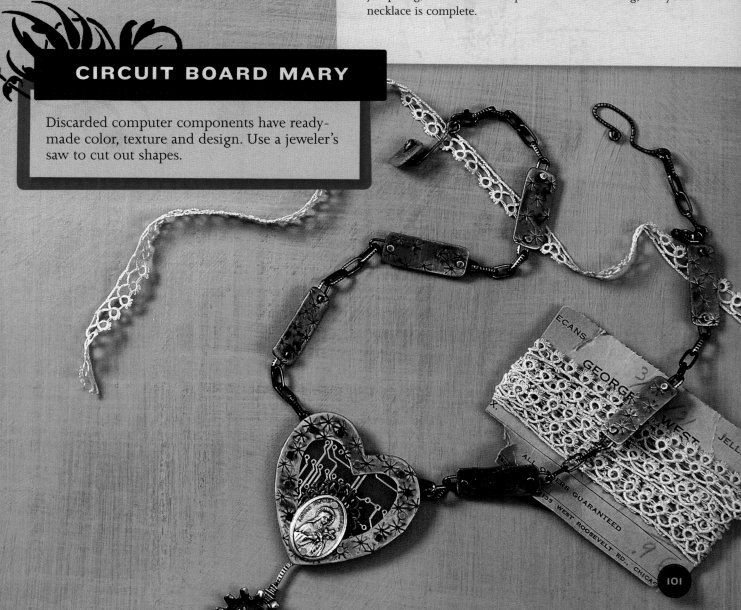

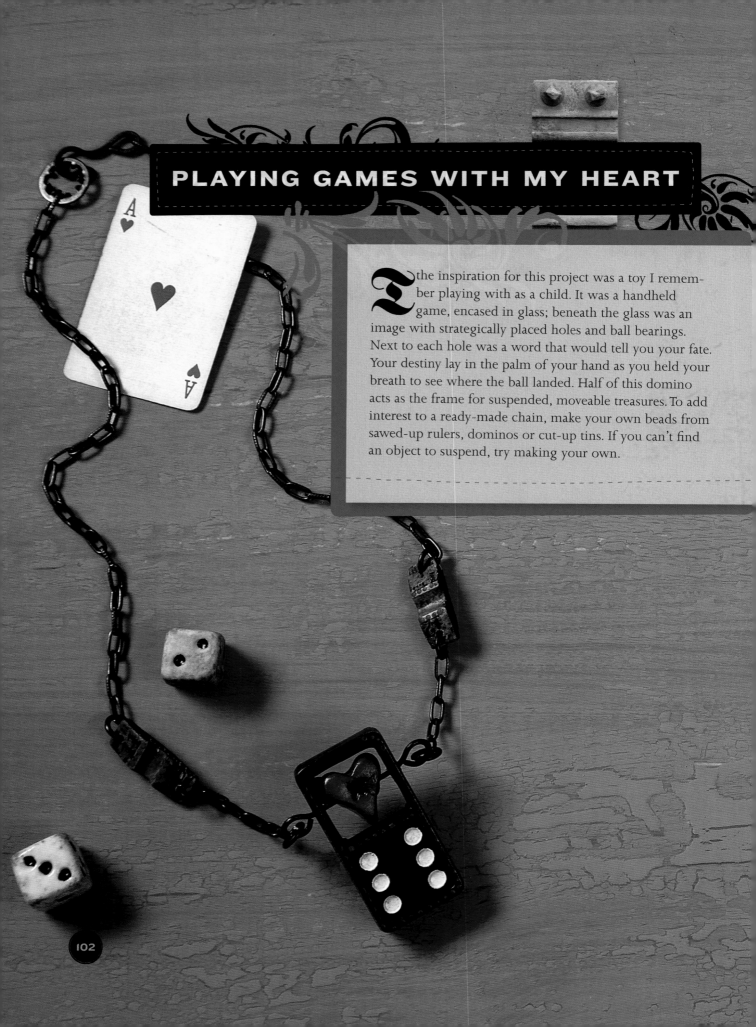

PLAYING GAMES WITH MY HEART

The inspiration for this project was a toy I remember playing with as a child. It was a handheld game, encased in glass; beneath the glass was an image with strategically placed holes and ball bearings. Next to each hole was a word that would tell you your fate. Your destiny lay in the palm of your hand as you held your breath to see where the ball landed. Half of this domino acts as the frame for suspended, moveable treasures. To add interest to a ready-made chain, make your own beads from sawed-up rulers, dominos or cut-up tins. If you can't find an object to suspend, try making your own.

MATERIAL POSSESSIONS

- baling wire
- ready-made copper chain, about 18" (46cm)
- acrylic paint, black
- acrylic paint, red
- paintbrush
- polymer clay, Ivory Brilliant (Sculpey)
- spray sealer (Deft)
- ¼" (6mm) dowel
- wood domino
- old ruler
- internal washer
- retractable pencil
- sanding block
- drill with ¹⁄₁₆" (2mm) and ¼" (6mm) bits
- coping saw
- jeweler's vise
- bastard and smaller metal files
- pliers pack (see page 10)
- screwdriver
- hammer and metal block

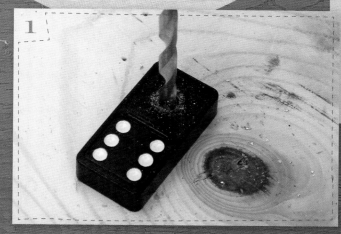

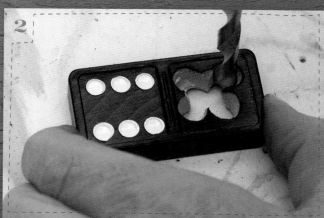

1 DRILL INTO DOMINO
Drill a hole into the lower portion of a domino using a ¼" (6mm) or similar-sized bit.

2 REMOVE CENTER BULK
Drill four or five more holes, just to remove a good portion of the center bulk.

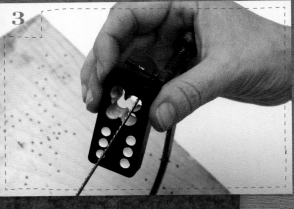

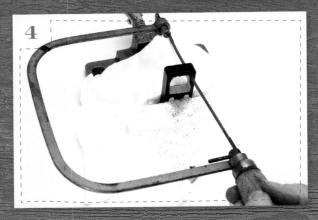

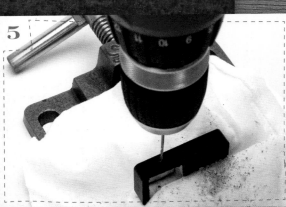

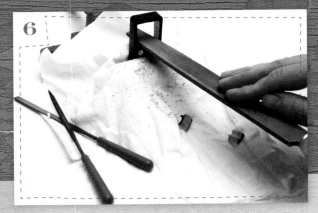

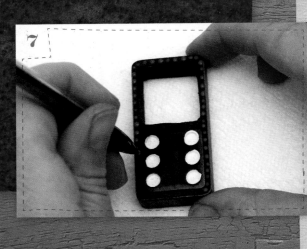

3 ENGAGE SAW THROUGH HOLES

Unlatch the blade of the coping saw and thread the domino onto the blade. Then reassemble the saw.

4 USE SAW TO CUT OUT WINDOW

With the domino in a vise (protect the domino with an old T-shirt or rag), cut away the interior of the lower domino half, to create a square window. Rotate the domino as needed to get the best leverage for each side.

5 DRILL HOLES AT SIDES

Remove the saw from the domino, and drill a hole through the two sides of the window with a $\frac{1}{16}$" (2mm) bit.

6 FILE ROUGH EDGES

Then, use a bastard file and smaller files to clean up the inside edges and corners.

7 ADD DETAILS TO DOMINO

Sand the surface of the domino a bit to distress it, using a sanding block. Paint the interior of the window with black acrylic paint. Add red dots to the perimeter of the domino using the retractable pencil. When it is dry, sand the dots a little bit to distress them, too.

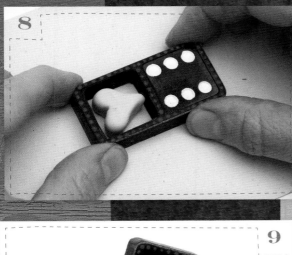

8 CREATE HEART FROM CLAY

Condition a small amount of polymer clay in your hands and shape it into a heart. Check to make sure the heart fits within the window.

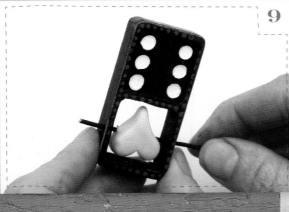

9 MAKE A HOLE THROUGH CLAY

Cut a 3" (8cm) length of baling wire and, while holding the heart in the window where you want it, insert the wire through the domino's holes and the clay.

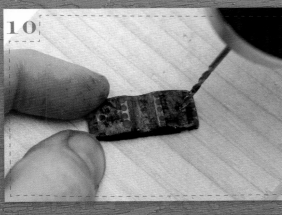

10 CREATE RULER LINKS

Remove the wire and clay and, using the wire, make the hole in the clay heart just a tiny bit larger so there's room for it to move. Create an X on the front of the heart, using a screwdriver. Check to make sure the wire still goes through the clay, and then bake it according to the package directions.

Put the ruler in the vise and, with the hacksaw, saw off two sections that are about ⅜" (10mm) wide. Sand the pieces to remove the rough edges and then mute the color a bit with a black acrylic paint wash. When dry, apply red dots, as you did on the domino, and then drill a hole in each end, using the ¹⁄₁₆" (2mm) bit.

11 ASSEMBLE CHAIN

Create six jump rings from the baling wire using a ¼" (6mm) dowel (see page 84) and hammer them a bit to flatten them. Attach one jump ring to each hole in the two ruler pieces. Dip a section of copper chain into liver of sulfur, rinse and dry. Using the jump rings, attach about 1½" (4cm) of chain to the bottom of each ruler link, and about 8" (20cm) of chain to the other ends of the ruler links. Create a toggle from wire and an internal washer. Attach those to the long ends of the chain.

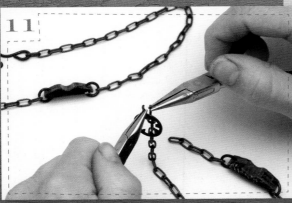

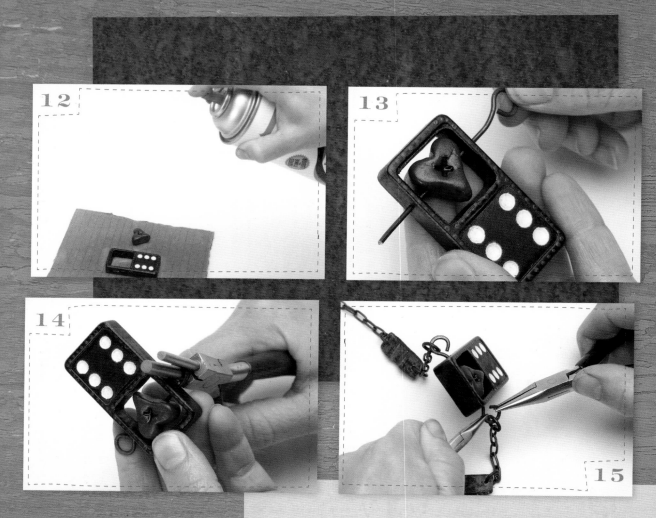

12 PAINT AND SEAL HEART

Paint the baked heart with red acrylic paint and the X with black acrylic paint. Give the heart and the domino a coat of spray sealer.

13 THREAD WIRE THROUGH HEART

Cut a 3" (8cm) piece of baling wire and curl one end, and then hammer the end flat. Thread the wire through the domino and the heart.

14 CURL OTHER END OF WIRE

Curl the other end of the wire and hammer it as well.

15 ATTACH DOMINO TO CHAIN

Attach the domino piece to the short ends of the chain with two more jump rings.

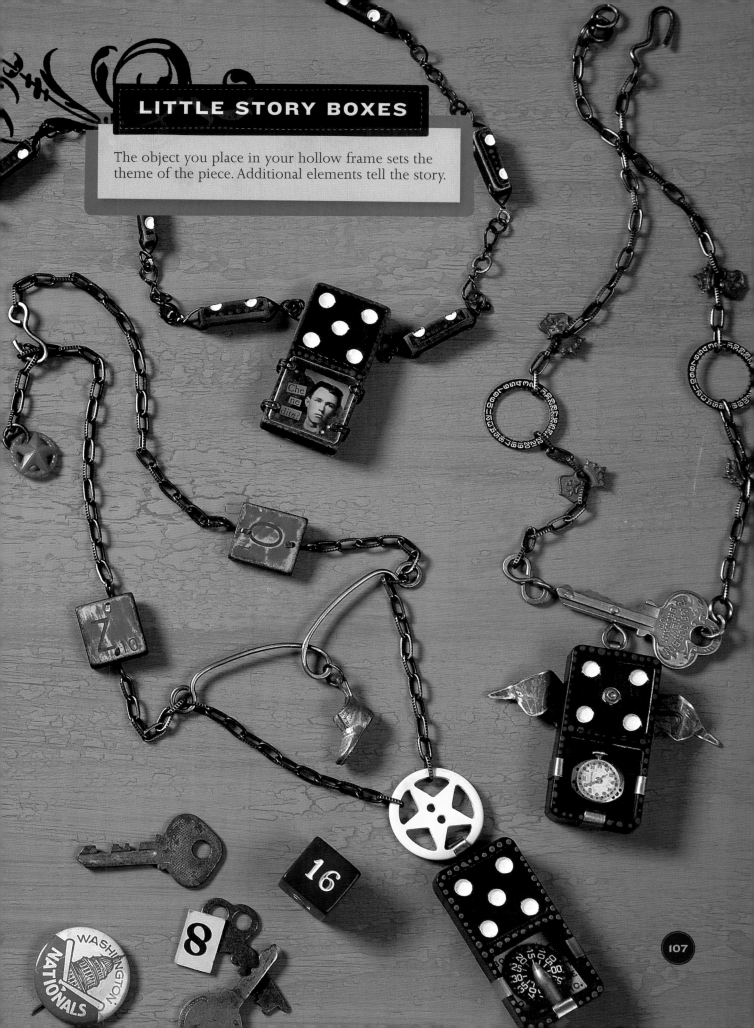

LITTLE STORY BOXES

The object you place in your hollow frame sets the theme of the piece. Additional elements tell the story.

I'LL FLY AWAY

With smoking out of fashion, old cigarette tins have the opportunity to take on politically correct lives as wings. Rivets not only fasten pieces together, they are also a great way of adding design elements. There are numerous ways of making a rivet; I've found the method shown here to be the easiest. Finally, for a different effect on the wire bail, sand it to create a pewter look. The more you sand, the shinier it gets; the end result is a matter of personal choice.

MATERIAL POSSESSIONS

* baling wire
* ready-made copper chain, about 18" (46cm)
* liver of sulfur
* old tin
* ¼" (6mm) dowel
* tag
* key
* external washers, four
* internal washer
* ⅛" (3mm) eyelet and eyelet setter
* pliers pack (see page 10)
* scribe tool
* metal shears
* sanding block
* drill with 1/16" (2mm) and ⅛" (3mm) bits
* hammer and metal block
* jeweler's vise
* detail metal file
* bastard file

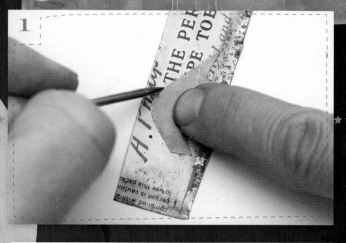

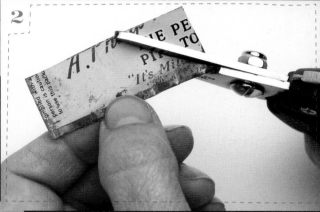

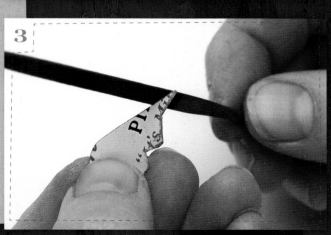

1 SCRIBE WING SHAPES ONTO TIN
Cut a wing shape out of a flat piece of a tin, and then flip it, to scribe a second wing. (If you like, you can use the template on page 122.)

2 CUT OUT SCRIBED SHAPES
Cut out the other wing with shears as well.

3 FILE OFF BURRS
File the edges to remove any burrs, using a small detail file.

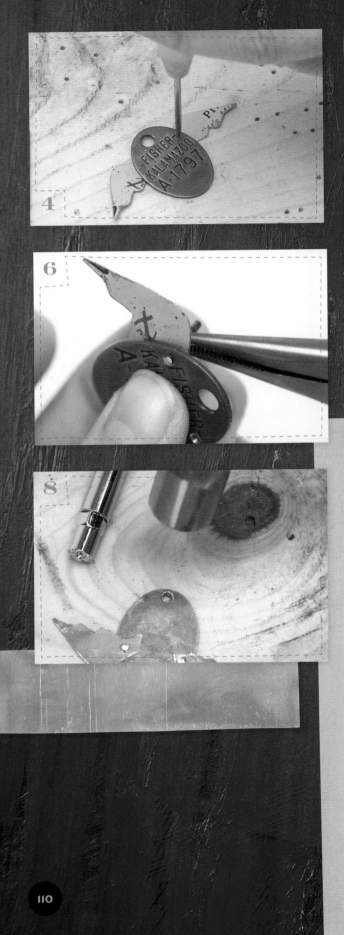

4 MARK HOLES FOR WINGS
Use a scribe to mark where you want your rivets to attach the wings. Drill a ¹⁄₁₆" (2mm) hole at that mark. Then put the wings under the tag, and mark where you want the wings' holes to be.

5 CREATE FIRST SIDE OF RIVET
Drill holes at these marks on the wings. Cut two pieces of wire to about 1" (3cm). If the cut end of the wire is not flat, file it flat with a bastard file. Put the first wire in a vise, with the end about ¹⁄₁₆" (2mm) above the top of the vise. Begin tapping the end of the wire around the edges to splay the end out like a mushroom. Continue until you have a nice, round shape.

6 THREAD RIVET THROUGH WING
Insert the unflattened end of the wire through the tag and then through a wing.

7 COMPLETE RIVETS
Trim the wire in the back, leaving about 1mm. (Try to cut the wire as flat as possible.) Set the piece on a metal block, with the cut end up. Hammer the wire the same way, tapping it around the outside to flatten it. Periodically, flip the piece over and hammer from the front some more. Repeat this for the other wing and rivet.

8 SET EYELET IN TAG
Drill a ¹⁄₈" (3mm) hole in the bottom of the tag and, using an eyelet setter, set one eyelet.

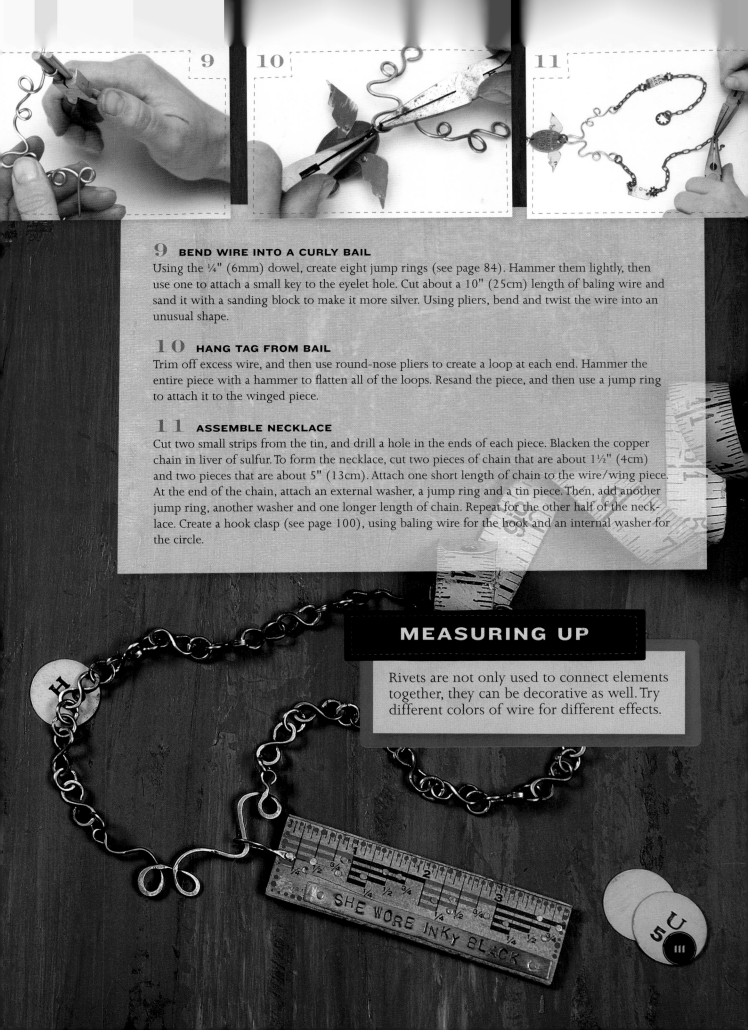

9 BEND WIRE INTO A CURLY BAIL

Using the ¼" (6mm) dowel, create eight jump rings (see page 84). Hammer them lightly, then use one to attach a small key to the eyelet hole. Cut about a 10" (25cm) length of baling wire and sand it with a sanding block to make it more silver. Using pliers, bend and twist the wire into an unusual shape.

10 HANG TAG FROM BAIL

Trim off excess wire, and then use round-nose pliers to create a loop at each end. Hammer the entire piece with a hammer to flatten all of the loops. Resand the piece, and then use a jump ring to attach it to the winged piece.

11 ASSEMBLE NECKLACE

Cut two small strips from the tin, and drill a hole in the ends of each piece. Blacken the copper chain in liver of sulfur. To form the necklace, cut two pieces of chain that are about 1½" (4cm) and two pieces that are about 5" (13cm). Attach one short length of chain to the wire/wing piece. At the end of the chain, attach an external washer, a jump ring and a tin piece. Then, add another jump ring, another washer and one longer length of chain. Repeat for the other half of the necklace. Create a hook clasp (see page 100), using baling wire for the hook and an internal washer for the circle.

MEASURING UP

Rivets are not only used to connect elements together, they can be decorative as well. Try different colors of wire for different effects.

SHE WORE INKY BLACK

ETCHED IN MY BRAIN

The transfer product used in this project provides a simple, low-cost solution for transferring images onto metal. Once the image is transferred, it creates a resist for the etching process. This means you can transfer your own drawings or high-contrast photographs onto any metal surface that can be etched. While you could easily use this application in creating pendants, bracelet charms or earrings, the project here takes things beyond the jewelry realm and onto a larger scale.

MATERIAL POSSESSIONS

- 14-gauge copper wire
- 28-gauge copper wire
- 20-gauge annealed wire
- 22- to 24-gauge sheet copper
- image
- laser printer or photocopier
- cardstock, black
- etching paper (Laser-ready PnP Blue)
- baking soda and old toothbrush
- permanent marker
- alcohol and cotton balls
- PCB etchant solution
- liver of sulfur
- beeswax and rag

- scrap of tooled leather, such as from an old bag
- carpet tape or very sticky masking tape
- micro nuts and bolts, or brads, four
- drill and 1/16" (2mm) bit
- metal shears
- scribe tool
- ruler
- bone folder
- iron
- sandpaper or sanding block
- pliers pack (see page 10)
- rubber mallet
- hammer and metal block

1 PREPARE SHEET COPPER

Print out a toner copy of your image onto the etching plastic paper. Trim the image to leave about 1/4" (6mm) of space outside of the image. Trim a piece of copper a bit larger than the desired finished size and sand both sides. Hammer it very smooth and flat with the rubber mallet. Clean both sides with cotton and alcohol.

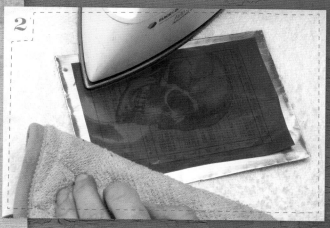

2 TRANSFER IMAGE

Put the iron on a setting between cotton and linen to start. Test the iron on a scrap of the etching material to make sure that it doesn't melt the plastic. (If it does, lower the heat setting.) Set the copper on a towel or ironing board, and then put the material, image side down, on the copper. Iron the piece for the recommended amount of time.

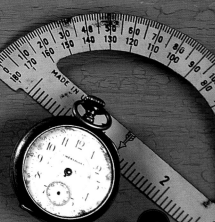

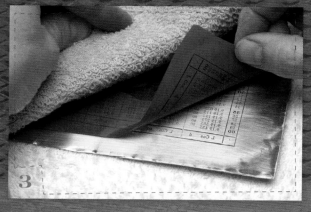

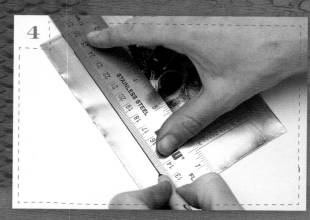

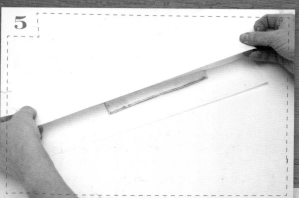

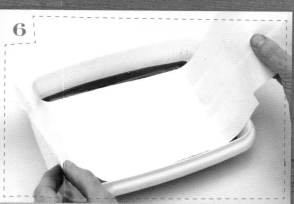

3 CHECK TRANSFER
Test the corner of the piece by peeling it back to make sure the image transferred. If not, apply the iron for a bit longer.

4 TOUCH UP FAINT AREAS WITH PEN
If any areas of the image did not transfer, you can go over them with a permanent marker.

5 APPLY TAPE TO DESIRED AREA
Apply tape to any areas of the metal that you don't wish to be etched (like the back) with tape. Burnish it with a bone folder.

6 SET COPPER IN SOLUTION
Set the piece, tape side up, into a container filled with etching solution.

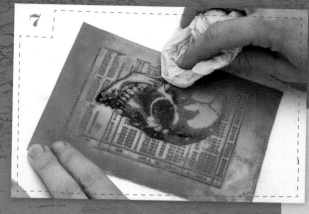

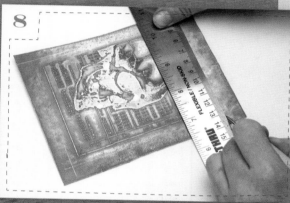

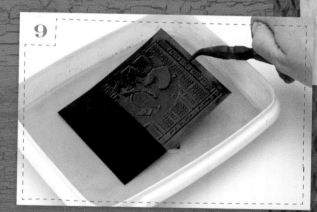

7 RINSE AND DRY COPPER SHEET

Leave the piece in the solution for at least an hour. Rinse the piece and remove the tape. Sprinkle baking soda over the copper and use an old toothbrush to scrub it in, and to neutralize the solution. Rinse the piece again, then pat dry.

8 SAND AND TRIM SHEET

Sand off all of the toner and any material left over from the plastic paper. Use a scribe to mark where you wish to trim the piece. Here, I am ruling a line that leaves about ¼" (6mm) of space outside of the etched line.

9 BLACKEN COPPER

Use shears to trim along the scribed line. Put the piece in liver of sulfur until it is nice and black.

10 SAND RAISED AREAS

Use the sanding block to remove the black over the raised areas.

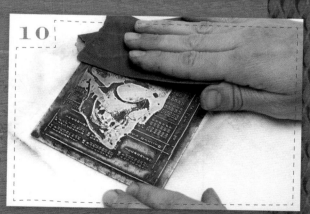

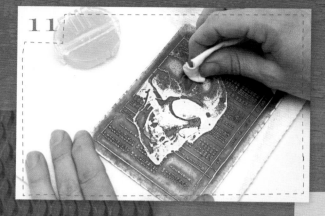

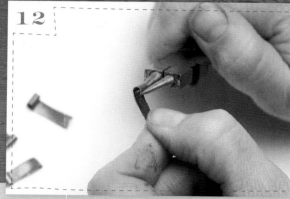

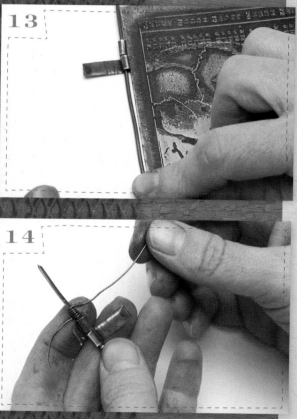

11 POLISH COPPER WITH WAX

Apply some beeswax with a rag to the metal and polish it up.

12 CREATE SPINE AND HINGES

Cut a spine that is the same height as the cover and about ½" (13mm) wide (I was able to use a portion that I cut off from the first sheet), and blacken it in the liver of sulfur solution. Rinse, dry, sand and wax this piece as well. Set the cover and spine aside. Cut a piece of 14-gauge copper wire to the height of the cover and make it as straight as you can. Put it in the liver of sulfur, rinse and dry. Cut a piece of copper to 1" × ¼" (3cm × 6mm), and curl the end with the tip of round-nose pliers. These will serve as hinges.

13 THREAD WIRE THROUGH HINGES

Flatten the tail part of the hinges with a rubber mallet, and then sand the burrs off with a sanding block. Dip the hinges in liver of sulfur, rinse and dry. Cut about 18" (46cm) of 28-gauge copper wire and dip it in liver of sulfur. Rinse and dry. Sand the hinges and the wire just a bit. Slip the hinges on the 14-gauge piece of wire and determine where you want them in order to attach to the cover. Use a scribe to mark for holes.

14 COIL WIRE AROUND SPINE WIRE

Start wrapping the 28-gauge wire tightly around the 14-gauge wire, starting at the mark and wrapping for about ½" (13mm) away from the mark. Repeat this for both sides of both hinge areas. Keep the coils very close together.

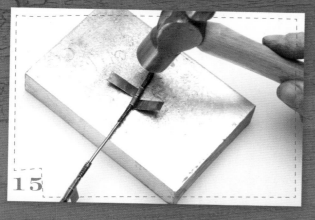

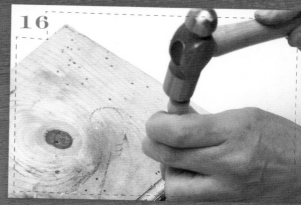

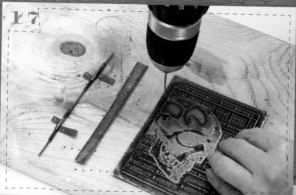

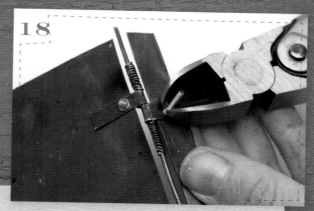

15 **HAMMER COILS**

Hammer each of the sections lightly.

16 **MARK HOLES FOR HINGES**

Trim the excess portion of the hinges where they overhang the spine. Then use a scribe to mark where the holes will be drilled.

17 **DRILL HOLES**

Drill all of the holes with a ¹⁄₁₆" (2mm) bit.

18 **SECURE HINGES WITH MICRO BOLTS**

Attach the cover to the spine at the hinges using micro nuts and bolts or brads. (Trim the excess bolt from the nut with cutters.)

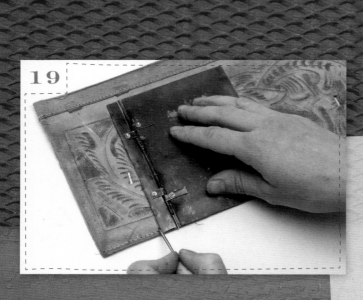

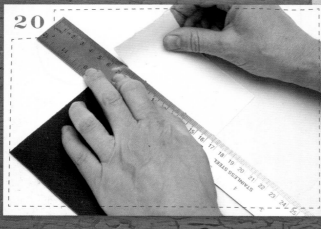

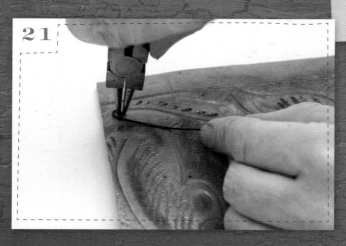

19 TRACE COVER ONTO LEATHER

For the back cover, which is leather, trace the entire front cover over the leather with a scribe.

20 TRIM PAPER FOR PAGES

Cut out the leather shape. To add pages for the inside, I like to always have black paper as the first and last pages. Trace the front cover over black cardstock and trim the cardstock about ⅛" (3mm) smaller, tearing it with a ruler. Repeat for the interior pages, using a black page as a guide. Create as many pages as you like. I use about eight.

21 SECURE LEATHER TO JOURNAL

Drill two holes, centered in the spine, about ¾" (19mm) from the top and bottom. Then use the cover as a guide to drill holes through the stack of paper and the leather back cover. Cut a length of 20-gauge annealed wire and make a flat coil on one end. Thread the wire through the front of the cover, the pages and the back cover, and then trim the wire to about ½" (13mm) and create a second coil on the back. Repeat for the other hole.

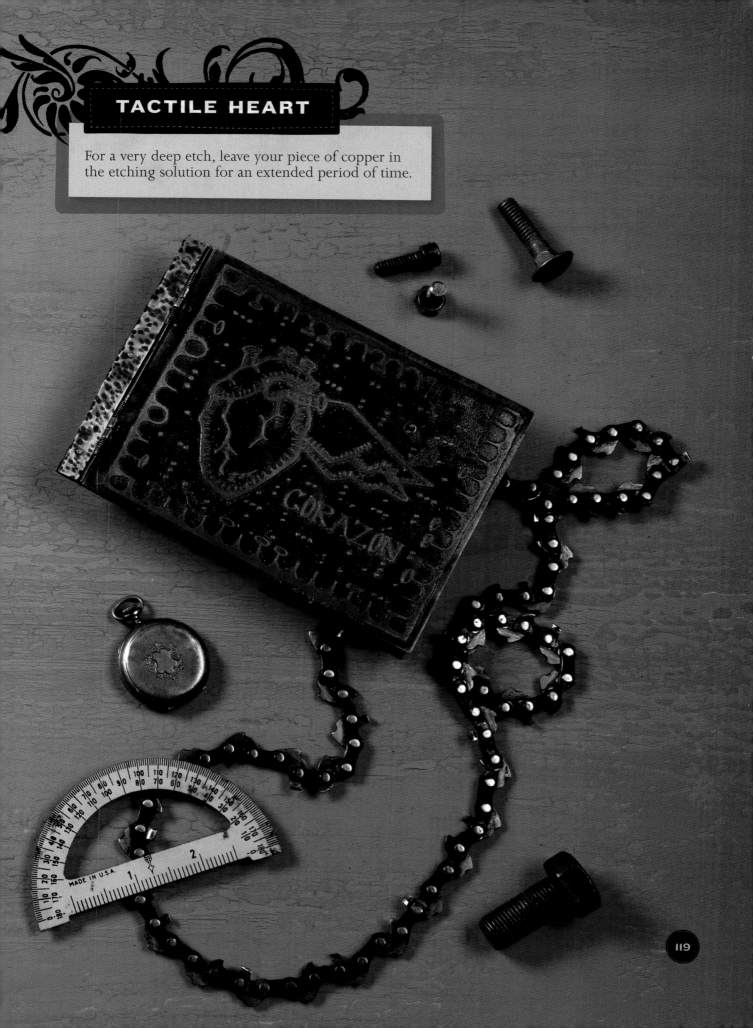

TACTILE HEART

For a very deep etch, leave your piece of copper in the etching solution for an extended period of time.

Use this template to create Twist of Fate (see page 14).

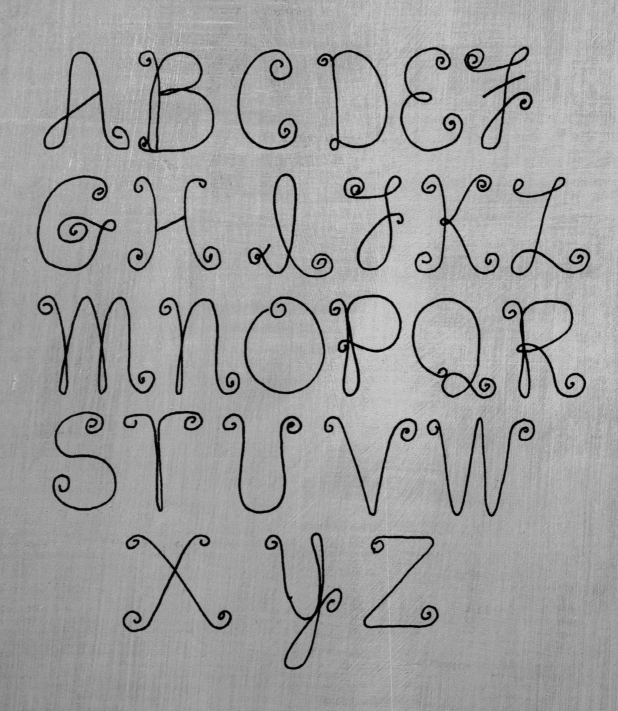

Use this template to create Curves Ahead (see page 17).

1 2 3 4 5
6 7 8 9 0

Use this template to create *I'll Fly Away* (see page 108).

Use this template to create *She Sees All* (see page 34).

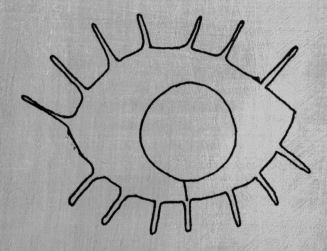

Use this template to create *Hanging Out* (see page 42).

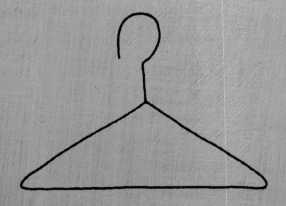

Use this template to create With These Wings (see page 30).

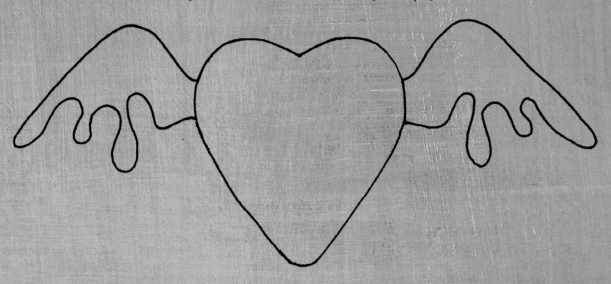

Use this template to create My Checkered Past (see page 72).

ADHESIVES

ALEENE'S
www.aleenes.com

GLOSSY ACCENTS
www.rangerink.com

GOLDENS GEL MEDIUM
www.goldenpaints.com

COLLAGE SHEETS AND SUPPLIES

ALPHA STAMPS
www.alphastamps.com

ANIMA DESIGNS
www.animadesigns.com

ARTCHIX STUDIO
www.artchixstudio.com

DOVER PUBLICATIONS
http://store.doverpublications.com

MANTO FEV
www.mantofev.com

PAPER WHIMSY
www.paperwhimsy.com

PAPIER VALISE
www.papiervalise.com

STAMPINGTON & COMPANY
www.stampington.com

JEWELRY SUPPLIES

ACE HARDWARE
www.acehardware.com

BEADS GALORE
www.beadsgalore.com

LONNIE'S, INC.
www.lonniesinc.com

MAKING MEMORIES
www.makingmemories.com

MICRO FASTENERS
www.microfasteners.com

RIO GRANDE
www.riogrande.com

VOLCANO ARTS
www.volcanoarts.biz

PAINT, INKS, PASTELS AND SUCH

AMERICAN ACRYLIC PAINT
www.decoart.com

INKADINKADO CHALK
www.inkadinkado.com

PORTFOLIO OIL PASTELS
www.portfolioseries.com

SAKURA OF AMERICA
www.gellyroll.com

STEWART SUPERIOR
www.stewartsuperior.com

TSUKINEKO
www.tsukineko.com

SCRAPBOOK PAPER

BASIC GREY
www.basicgrey.com

DAISY D'S
www.daisydspaper.com

DESIGN ORIGINALS
www.d-originals.com

FOOF-A-LA
www.autumnleaves.com

K&COMPANY
www.kandcompany.com

RUSTY PICKLE
www.rustypickle.com

7GYPSIES
www.sevengypsies.com

SHRINK PLASTIC

SHRINKY DINKS
www.shrinkydinks.com

SILK SCREENING AND ETCHING SUPPLIES

PHOTOEZ AND VERSATEX
www.ezscreenprint.com

PNP BLUE TRANSFER FILM
www.thompsonenamel.com

RADIO SHACK
www.radioshack.com

STAMPS

HERO ARTS
www.heroarts.com

INVOKE ARTS
www.invokearts.com

MOON ROSE ART STAMPS
www.themoonroseartstamps.com

STAMPERS ANONYMOUS
www.stampersanonymous.com

STAMPOTIQUE ORIGINALS
www.stampotique.com

INDEX

ABOUT JOSIE

If you would have told me three years ago that I would be crafting for a living and publishing my second book, I would have laughed out loud. *Collage Lost and Found* has been out for over two years, and since its release I have been featured on *Craft Lab*, contributed artwork to different publications, started my own wholesale line of jewelry and gift items, and expanded that line as demand grew. I am grateful to have been given the opportunity to earn a living at something I enjoy. Please visit my Web site, www.inkyblackpaperarts.com, where you'll find updates on events, classes and contact information. Thank you.

LOOK FOR INSPIRATION
FROM THESE OTHER
NORTH LIGHT BOOKS

COLLAGE LOST AND FOUND
GIUSEPPINA "JOSIE" CIRINCIONE

Inside *Collage Lost and Found*, you'll learn how to find and use old photographs, memorabilia and ephemera to create collage work inspired by your heritage. Drawing from her own Sicilian background, author Josie Cirincione shows you how to examine your own history for inspiration, as well as tips on where to look and what to look for. Then you'll choose from 20 step-by-step projects that use basic collage, jewelry-making and image transfer techniques to make sassy projects to decorate with, wear and give away as gifts.

ISBN-IO: I-58I80-787-2
ISBN-I3: 978-I-58I80-787-5
paperback 128 pages 33461

ALTERED CURIOSITIES
JANE ANN WYNN

Discover a curious world of assemblage with projects that have a story to tell! As author Jane Wynn shares her unique approach to mixed-media art, you'll learn to alter, age and transform odd objects into novel new works of your own creation. Step-by-step instructions guide you in making delightfully different projects that go way beyond art for the wall—including jewelry, hair accessories, a keepsake box, a bird feeder and more—all accompanied by a story about the inspiration behind the project. Let *Altered Curiosities* inspire you to create a new world that's all your own.

ISBN-IO: I-58I80-972-7
ISBN-I3: 978-I-58I80-972-5
paperback 128 pages Z0758

MIXED-MEDIA MOSAICS
LAURIE MIKA

Learn to craft highly textural and vividly colored icons, boxes, tables, items of personal adornment and more using a combination of manufactured and handmade tiles. Step-by-step demos will teach you to make your own polymer clay tiles using techniques such as painting and glazing, stamping, embedding items like beads and buttons, mixing pigments and mica powders with clay, adding metallic leaf, and more. Also included are ideas and techniques helpful for personalizing your artwork by adding stamped letters to spell out a special name, or by incorporating ephemera or found objects to commemorate a memorable trip or event.

ISBN-IO: I-58I80-983-2
ISBN-I3: 978-I-58I80-983-I
paperback 128 pages Z0823

SEMIPRECIOUS SALVAGE
STEPHANIE LEE

Create clever and creative jewelry that tells a story of where it's been, as metal, wire and beads are joined with found objects, some familiar and some unexpected. You'll learn the ins and outs of cold connections, soldering, aging, wire wrapping, plastering, resin work and more, all in the spirit of a traveling expedition.

ISBN-IO: I-60061-019-6
ISBN-I3: 978-I-60061-019-6
paperback 128 pages ZI281